Folkestone Triennial

TALES OF TIME AND SPACE

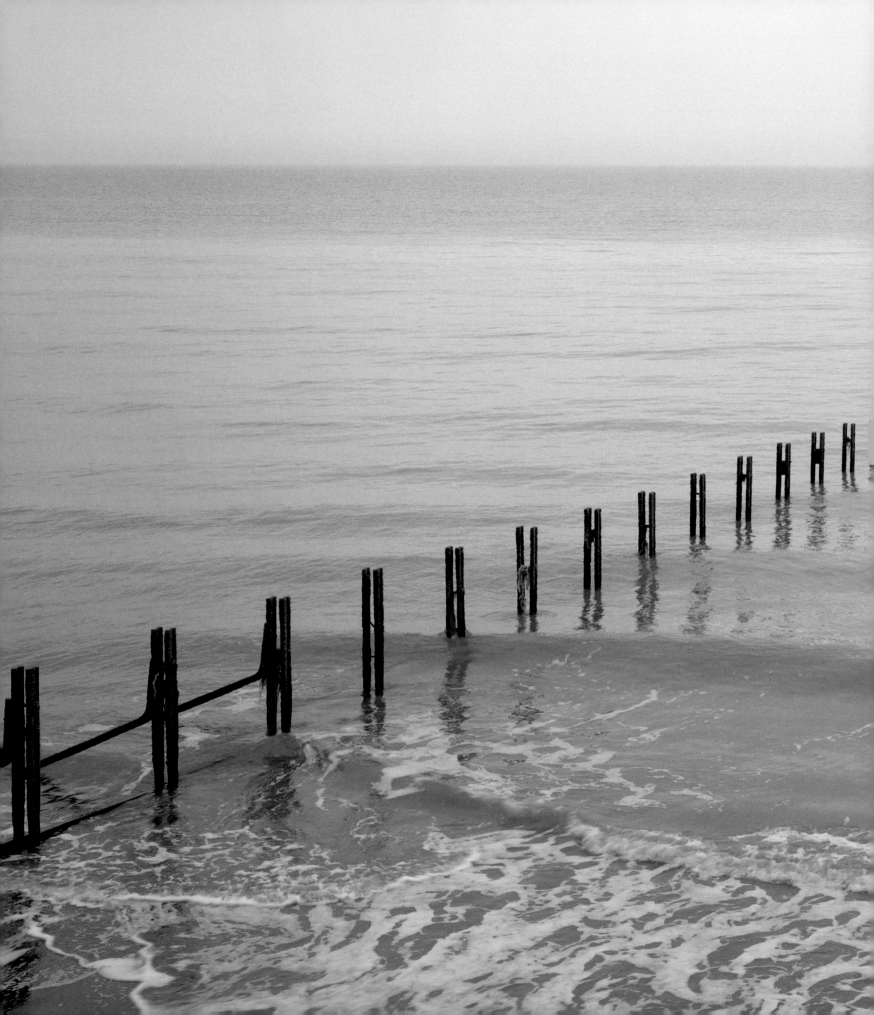

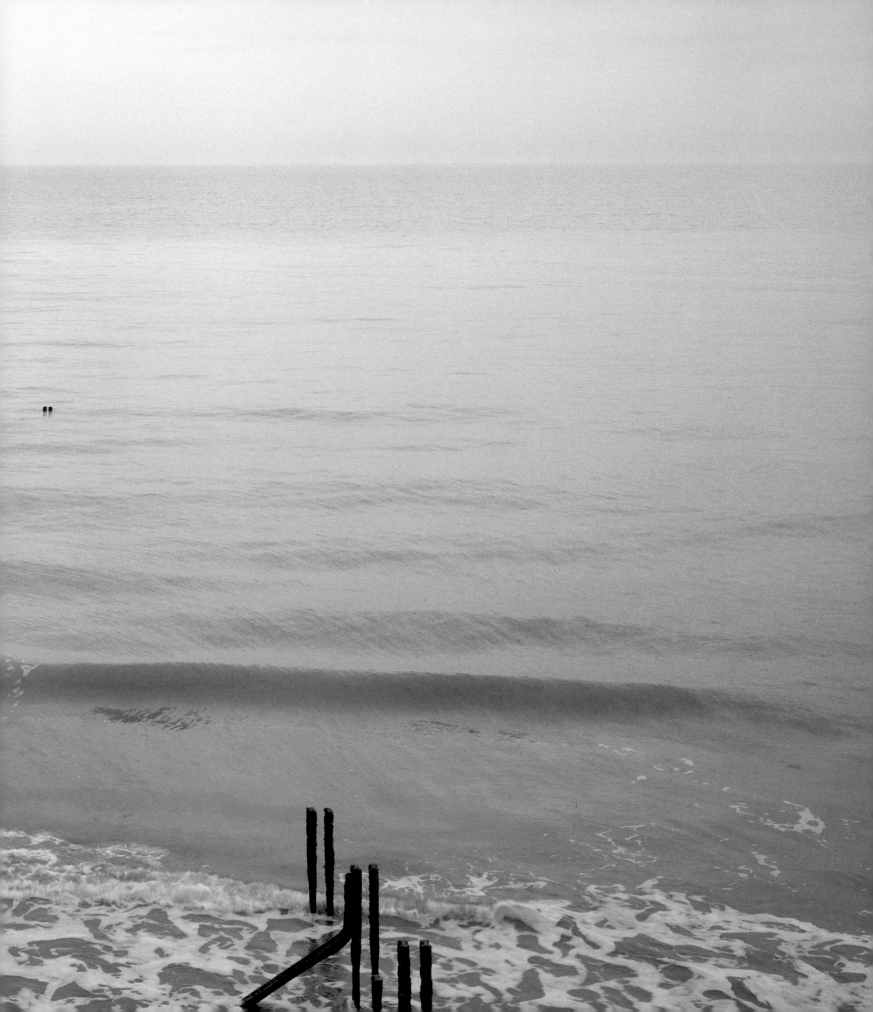

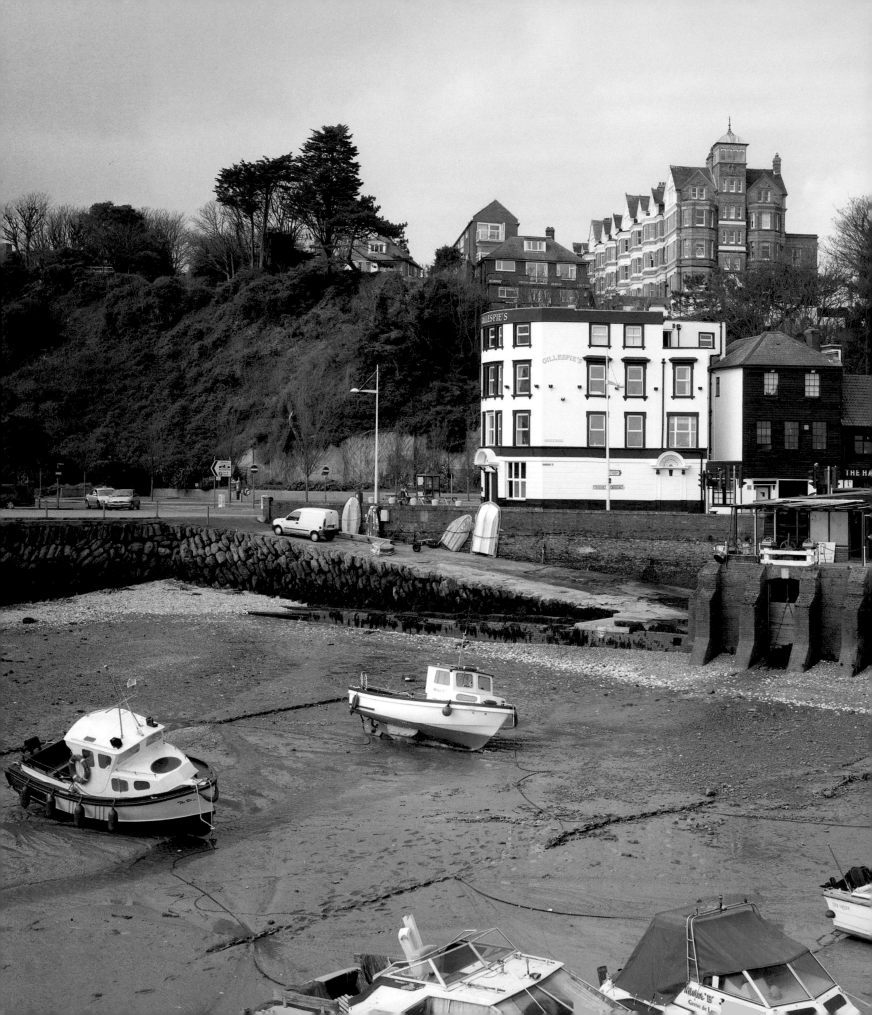

Folkestone Triennial

TALES OF TIME AND SPACE

Edited by Andrea Schlieker

Publication supported by
The Henry Moore Foundation
and The Folkestone Estate

The Henry Moore
Foundation

The Folkestone Estate

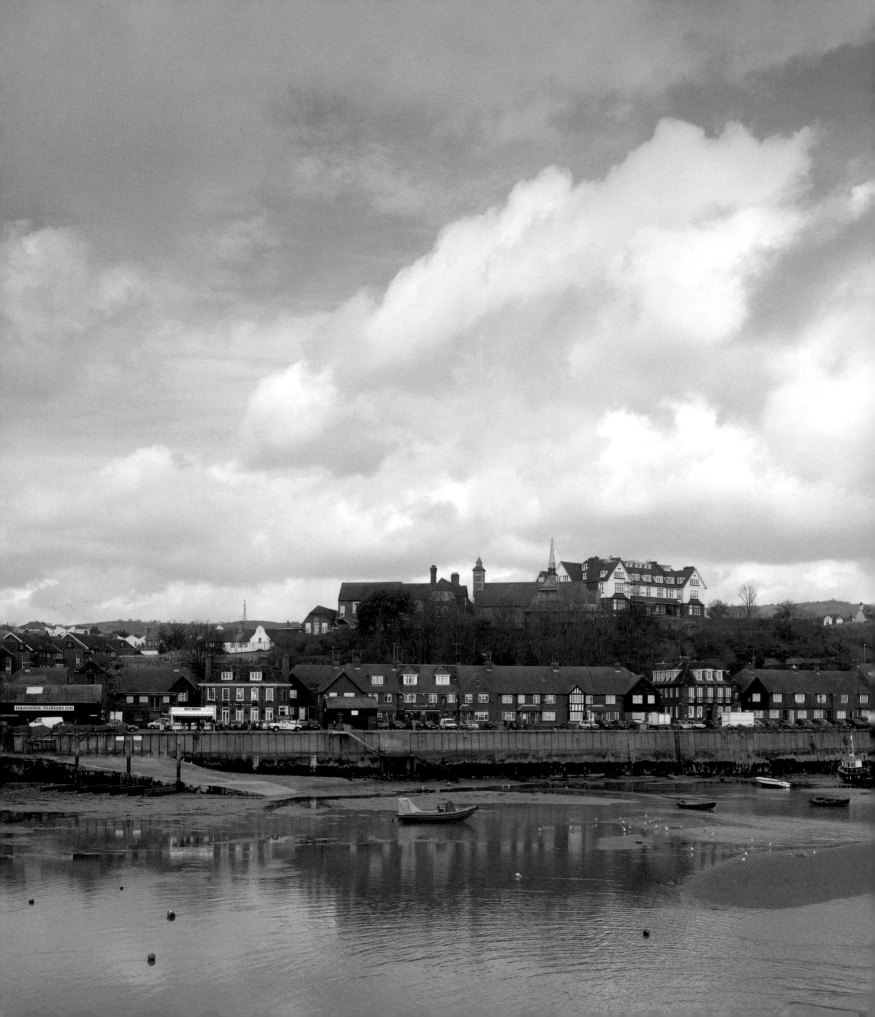

CONTENTS

8 FOREWORD *Nick Ewbank*

10 PREFACE *Andrea Schlieker*

12 TALES OF TIME AND SPACE *Andrea Schlieker*

26 ARTISTS' TEXTS AND IMAGES

116 LOCATIONS/MAP

118 THANKS & ACKNOWLEDGMENTS

FOREWORD

The Folkestone Triennial is the flagship cultural event in an ambitious and wide-ranging programme of arts-led regeneration for the town.

The regeneration project has been overseen for the past six years by a forward-thinking group of charity trustees, chaired by Roger De Haan CBE, former owner of Saga, the area's largest employer. It could not have been conceived without the collective vision of these trustees, nor, indeed, the philanthropy and generosity of their chairman. Trustees Timothy Llewellyn OBE, Dr Stephen Deuchar and Viscount Folkestone have all contributed unstintingly to the development of the Triennial with advice and practical support; Madeleine Bessborough of Roche Court has been our *éminence grise*.

Trustees had long debated the merits of establishing a permanent collection of art that could be exhibited in the public realm in Folkestone. Indeed, the original concept came from Henry Moore himself, who, in the early 1980s, exhibited at the Metropole Gallery on Folkestone's The Leas. He generously offered to lend some of his large-scale works for display on that glorious stretch of marine promenade overlooking the Channel and the French coast. Moore's offer was not taken up at the time, but it proved to be the spark that has, a quarter of a century later, grown into the flame of the Triennial.

The traditional model of a sculpture park, with monumental objects sited within defined boundaries, was felt to be inappropriate for an art project which sets out to engage a whole community in a process of self-enquiry and transformation, while at the same time moving forward the debate about the role of contemporary art in society. We needed a new model; a new approach. Once this decision was taken, it was clear to us that Andrea Schlieker should be our choice as curator, and we were fortunate indeed in securing her energetic commitment to the development and implementation of this inaugural Triennial. Drawing on her extensive experience in Britain and abroad, she developed the model of an exhibition which recurs at regular intervals, and which will, over time, leave a legacy of world-class art in the town's public places. For this first incarnation of the Triennial, she has brought together an outstanding cohort of contemporary artists to create work that responds directly to Folkestone, while having universal resonance.

And the Triennial is only part of the story. Building on a rich tradition of visual arts, literature, music and innovation in Folkestone and its environs, the Creative Foundation's objectives are threefold. First, to acquire empty, derelict and neglected properties in the old town and harbour areas, and to renovate them for occupation by artists and other creative people at affordable and sustainable rents as studios, workspace, retail and living space. Secondly, to establish a programme of festivals and events throughout the year, many of which will be taking place in the Creative Foundation's new purpose-designed performing arts and business centre, the Quarterhouse, which opens in late 2008. Thirdly, the Creative Foundation encourages and supports landmark opportunities in education for Folkestone's community, with an emphasis on the creative arts. Folkestone Academy, a state-of-the-art Foster and Partners secondary school, Kent County Council's new arts-based Adult Learning Centre and the new University Centre Folkestone, a joint venture between the Creative Foundation, Canterbury Christ Church University and the University of Greenwich, are all already operational and are beginning to transform levels of attainment and aspiration, particularly among young people, in the locality.

Linking together all these other initiatives, the Triennial will, over time, play a pivotal role in the development of Folkestone as a centre of international creative excellence, underpinned by deep cultural engagement for the whole community. I am sure it will offer challenges, pleasure and insights to many.

Nick Ewbank
Director
The Creative Foundation

PREFACE

The invitation from the Creative Foundation in the autumn of 2005 to devise an art project for Folkestone has been an extraordinary opportunity and challenge. It is not often that a curator has an open brief and the chance to work with a whole town. I am grateful for the trust of Roger De Haan and Nick Ewbank, and all the trustees.

A project as extensive and ambitious as the Triennial requires both strategic and tactical networking with large and varied groups of people and organisations, locally and also county and nationwide. There has been a real pioneering feel in encouraging these networks, setting up new social and cultural relationships and building awareness for the exhibition and its long-term effects.

The outcome of this invitation, the Folkestone Triennial, has been a long, fascinating, passionate and intense journey that is very much a team effort. I would like to thank my assistant curators, Niamh Sullivan, Jessica Wythe, Kim Dhillon and Martin Wills, who joined in succession as the project grew over time. Their diligence and sheer hard work contribute centrally to the success of this project. Sigrid Wilkinson has been a stalwart and intelligent fundraiser, forging and nurturing a groundswell of support. The education team – Vivien Ashley, Helen Hayward and Rachel Steward – have created a powerful Access and Learning programme to fit the inclusive ethos of the Triennial and, together with Kevin McGarry, have developed important networks within Folkestone's diverse communities. Emma-Jayne Taylor and Dan Porter produced inspirational education material for younger visitors.

The entire team at the Creative Foundation have been enormously supportive and their expertise crucial, especially in relation to local liaison and technical feasibility, but also in terms of press, marketing and ensuring efficient roll-out. The property team, along with their advisors, expertly handled the many technical complexities the various artists' projects brought to light, and Nicky Sheehan and the events team made sure that council and local authorities were on board for a well-orchestrated delivery of the Triennial. Sarah Preece, Clore Fellow, and on secondment to the Triennial, provided useful research for audience development and visitor experience.

It was a pleasure to work with GTF on developing the visual identity as well as the catalogue design for the Triennial, and I would like to thank Huw Morgan and Andy Stevens for their thoughtful approach. Erica Bolton of Bolton & Quinn, with the assistance of Charlotte Burns, handled all national and international press and publicity with customary panache. In establishing the inaugural Folkestone Triennial as a serious player, their experience was invaluable. I am grateful to Phil Allison and his

team at Cultureshock Media for their help in producing and distributing this publication, and to Thierry Bal, Gautier Deblonde and Joel Tettamanti for their beautiful photography.

We have been working with a number of different fabricators in order to realise artists' projects that were beyond studio capacity. MDM Props took the lion's share of this, producing five large-scale works. Ian Lander of MDM has been exemplary in his commitment, precision and reliability.

Without the financial support of our various funders, this project would not have been possible. Their faith in our endeavour at a stage when all plans were still on paper was crucial. On behalf of the artists and the entire team I would like to express our gratitude and appreciation to The Roger De Haan Charitable Trust, Arts Council England, the Creative Foundation, Kent County Council, SEEDA, UBS, Bernard Sunley Charitable Foundation, The Henry Moore Foundation, Calouste Gulbenkian Foundation, Outset, The Folkestone Estate, Shepway District Council, Sky Arts, Southeastern, University Centre Folkestone, Goethe Institut, AFAA/Cultures France, Haunch of Venison, Jay Jopling/White Cube, Kent Community Foundation, Vitra and individual donors including Margaret Evans, Ben and Racheal Moorhead and Alan Willett.

Finally, our most sincere gratitude goes to the artists. For the past two and a half years they have given generously and unequivocally of their time, visited Folkestone frequently, and, when circumstances dictated, adjusted or changed their proposals. Their selected sites had to go through a rigorous and official process of permissions and checks from the local councils or landowners, neighbourhood committees, services and utilities, English Heritage, Health and Safety and the Highways Commission, and sometimes, after months, a long fought-for site was lost at the last hurdle. Their enthusiasm unflagging, the artists remained committed to the project throughout such setbacks, and their and our team's combined efforts in problem solving and troubleshooting often led to even better outcomes. I am delighted about the extraordinary and evocative works that have been produced at the end of this complex journey. They are testimony at once to the artists' intense engagement and to this town's powerful potential.

Andrea Schlieker
Curator
Folkestone Triennial
April 2008

TALES OF TIME AND SPACE

ANDREA SCHLIEKER

Wandering along the marine promenade, going to the shops or rushing to work, residents of Folkestone will encounter curious interventions and unexpected happenings in their town this summer: a gigantic model of a seagull with an ornithologist residing inside it; unannounced comic performances of amateur dramatics; a mobile science-fiction library housed inside a Green Goddess; an old fish market in the harbour, only visible at low tide… Extraordinary stories unfold, articulating times past and future, across hidden spaces and famous landmarks of the town.

All these sightings are part of the first Folkestone Triennial, a major summer-long exhibition of 22 special commissions by British and international artists, invading the streets, harbour and historic buildings to engage, challenge and delight visitors and residents alike. Using the town as a canvas, the artists articulate their diverse concepts through a wide spectrum of different media, from sculpture to sound, film to live performance, photography to installation. The resulting works are inspired by the specifics of the place they encountered, but are relevant far beyond, resonating with many universal issues.

The Triennial is an ambitious exhibition of newly created works for the public realm, which furthers the debate about place-making and makes explicit the dramatic changes in public art over the past twenty years. At the same time, it is the unique story of a town, sidelined and in decline for years, now in the process of reinventing itself on an astonishing scale through art and regeneration. Burgeoning artistic and cultural activity has long been associated with economic growth[1], but Folkestone is one of the most vibrant examples of a vision that recognises the importance of art and the improvement of a town as equal and interdependent.

1. See among others Richard Florida, *The Rise of the Creative Class* (Basic Books 2002), where he considers the "rise of human creativity as the key factor in our economy and society", p.4.

2. Miwon Kwon, "Public Art and Urban Identities", The European Institute for Progressive Cultural Politics (January 2002), para 8 of 12.

Culture has become a vital constituent of urban regeneration, and concurrently there has been a dramatic change in the role of the artist in the processes associated with it. The past decade or two have seen a shift from the single "auteur", working alone in the studio, towards the artist as collaborator, producer or service provider. Equally, the understanding of place has changed radically. While the modernist artist might not have considered it necessary even to inspect or visit the space where his sculpture was to be installed[2], the place itself became the all-important starting point for many artists of the 1970s and 1980s. The notion of site-specificity, so crucial since Richard Serra's *Tilted Arc* (1981-1989), rendered (publicly sited) work irrelevant unless it was anchored at the site it was made for. The 1987 Münster Skulptur Projekte postulated that the works commissioned there were "a first review of whether and how far contemporary sculpture can be local, specific to a site, made for a site, only made for a certain site and only for that site"[3].

The credo of site-specificity has undergone important shifts during the past twenty years, as the social context of a site became increasingly important. Place began to be widely understood as "social space", and the artist's work understood as "place-making" and "socially engaged practice". According to Miwon Kwon, a leading thinker on this subject, artists diverted their attention from the physical attributes of a site to themes of cultural identity and social history: "Moving beyond the inherited conception of site-specific art as a grounded, fixed (and even ephemeral), singular event, the work of [these] younger artists are [sic] seen to advance an altogether different notion of a site as predominantly an 'intertextually' co-ordinated, multiply-located, discursive field of operation"[4]. Collaboration and social engagement became the leading criteria in the 1990s. This was further highlighted by Nicolas Bourriaud's theory of "relational aesthetics" in the late 1990s, which propagated artistic approaches and methods that were to help us to "learn to inhabit the world in a better way"[5] via "micro utopias", interventions within and for a small community, rather than directed at society as a whole. Bourriaud states "the role of artworks is no longer to form imaginary and utopian realities, but to actually be ways of living and models of action within the existing real"[6]. He champions transitory social encounters, participation and open-endedness, aiming to undermine art as consumer object or commercial commodity. For Bourriaud, relational practices are a response to social alienation by creating meaning through other people.[7]

3. Georg Jappe, Introduction, Guide, *Münster Skulptur Projekte*, 1987, unpaginated.

4. Miwon Kwon, "The Wrong Place" in Claire Doherty, *From Studio to Situation* (Blackdog Publishing 2004), p.30.

5. Nicolas Bourriaud, *Relational Aesthetics* (Les Presses du Reel, 1995, Engl. transl. 2002), p.13.

6. Ibid.

7. See Claire Bishop's critique of privileging the social over the aesthetic, "The Palais de Tokyo", *October* 110, Fall 2004, pp.51-79. See also "The Social Turn: Collaboration and its Discontents", *Artforum*, March 2006, pp.178-183.

The artists' works for this inaugural Triennial exhibition have to be seen in the context of these changing and complex debates. 'Tales of Time and Space' therefore contains elements of the relational and the performative, the site-specific and the nomadic, the ephemeral and the lasting. Most of the artists chose to relate their work closely to the places they encountered, interweaving it with the history, culture and social context of the town. Yet the works' relevance reaches beyond the local and peripheral, and is astutely connected to the world beyond, probing themes as diverse as heritage and regeneration, immigration and teenage pregnancy, times past and people lost, Britishness and the uneasy connection with Europe, or tourism and the consequences of war.

I. HISTORY

Early Folkestone was a fishing village and trading port, prospering in medieval times and later becoming part of the Confederation of Cinque Ports with an obligation to provide ships and men to the Crown in return for trading freedom and privileges. In the early part of last century, it enjoyed a glamorous reputation as a fashionable seaside resort, attracting aristocracy and royalty, as well as artists and writers of the day. Charles Dickens and later H.G.Wells were residents, enticing other writers such as Bernard Shaw, Joseph Conrad, Ford Madox Ford and Henry James to spend time here. The town's mild climate, elegant villas and grand hotels, together with the convenience of its railway connections, contributed to making a stylish and busy tourist destination.

Located on one of England's closest points to mainland Europe, Folkestone was always a gateway. During the First World War more than a million soldiers sailed from here to fight on the battlefields of France and Flanders. Later, this proximity to France gave the town a regular ferry service to neighbouring Boulogne, and made it a stop-off point for the Orient-Express, which until last year still pulled into the (now run-down) harbour, bringing passengers on their way to Paris, Venice and Istanbul.

But the advent of package holidays in the 1960s and cheap air travel marked the end of Folkestone's halcyon days and led to rapid decline. The tourist industry vanished, hotels and shops stood empty. The opening of the Channel tunnel in the 1990s rang the death knell for the ferry, and, along with the rest of east Kent, Folkestone suffered also from the decline of fishing, agricultural problems and the collapse of the region's coal mining. Consequently, parts of the town became some of the most deprived in Britain, with an ageing population, high rates of crime, unemployment[8] and teenage pregnancy, failing schools and little commercial activity.

In a concerted strategy to reverse Folkestone's failing fortunes, the Creative Foundation, set up in 2003 by local businessman and philanthropist Roger De Haan, launched one of the country's largest multi-agency regeneration projects. Addressing the town's many challenging problems, the Creative Foundation has developed an innovative programme which focuses on education and the arts as the main tools for driving change. Dilapidated buildings are being restored, the defunct harbour is to be become a busy hub again, a new secondary Academy school (designed by Foster and Partners) has recently opened and, to halt the youth drain, a new university – the town's first – started with courses for arts and business students in 2007. The Literary Festival has been successfully established as an annual event, and a Performing Arts Centre will be inaugurated in autumn 2008. The arts are seen as key to a policy of improving the public realm, raising educational attainment, generating employment and economic development, tackling the causes of social deprivation and developing a renewed sense of community. With the Folkestone Triennial, the town has an opportunity to become a major centre of creativity in the south-east, bringing new standards of excellence to the region, and making Folkestone a magnet once again for visitors from this country and abroad.[9]

8. Folkestone features some of the highest levels of deprivation in the south-east, particularly in its central and eastern districts. For example, Folkestone Harvey Central ward, which is the focus for the Creative Quarter and much of the Triennial, is ranked worst in Kent for health deprivation and worst in the south-east (out of 5,139 wards) for employment, putting it in the bottom 0.4 per cent nationally. East Folkestone has 40 per cent unfit housing (overcrowding, damp, lack of basic facilities). In 2003 only eight per cent of pupils at Channel School (which serves central and eastern Folkestone) achieved five GCSE A*-C grades, making it the fourth poorest performing secondary school in the country. A high percentage of the working-age population is in long-term unemployment (34.32 per cent) and has no formal qualifications. Reported crime is high.

9. Part of this essay also appears in Andrea Schlieker, "Tales of Time and Space: Art and Regeneration. The first Folkestone Triennial" in *Out of the studio! A symposium on art and public space*, ed. Jan Debbaut, Monique Verhulst, Pieternel Vermoortel (Hasselt: Z33 Art Centre, Belgium, 2008).

Martello Tower 3

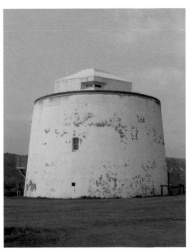

II. THE TRIENNIAL

Folkestone may not seem the most obvious setting for a major international exhibition. But it is in the context of its extraordinary and energetically pioneering transformation that the Triennial plays its important part. Sensitivity to local history and social make-up had to be a prerequisite for any successful integration of an art project into the fabric and community of this long-declining seaside town.

Plans for the Triennial started in the summer of 2005, when I was invited by the Creative Foundation to visit Folkestone and develop a concept for an art project. Never having been to the town before, I was immediately struck by the evident though faded grandeur of the place, its charm only heightened by its rough edges. The magnificent Martello towers and the elegant marine promenade with its grand

hotels and white stucco villas in the west, but equally the cobbled streets in the deserted east, the non-operational harbour with its lovely lighthouse, the crumbling amusement park by the shore; these, together with the fact that Duchamp had played chess and Samuel Beckett had married in Folkestone, that Derek Jarman's enchanted garden is only a stone's throw away, and also that the town has long been a place of arrival and shelter for many refugees, all became intriguing markers on an increasingly fascinating map and timeline. The ebb and flow of Folkestone's fortunes over the past century, the wealth of its history, the famous names and amazing architecture suggested the place had stories to tell. It seemed to be an ideal context within which artists could evolve a pertinent response.

From this visit sprang the idea of an exhibition that would use the whole town, its geography, its community, its history, and the hints, atmosphere and stories these contain. It seemed fundamental that this should not be a one-off exhibition, but that, by repeating it every few years, Folkestone could contribute to furthering the debate about art in public places, and its stimulating and regenerative values, as well as being taken seriously as a main player in the international arena. The combination of temporary and permanent works would be another important element, so that over time, following an established tri-annual rhythm, a significant number of pieces could be permanently sited, maintaining focus on the town's major importance in developing and extending internationally the practice of contemporary public art. The Triennial will thus act as a kind of barometer for the way art in the public realm alters over the years. Debates have moved on radically, and so have and will artists' ways of engaging with an urban situation.

Münster Skulptur Projekte has been an active model and inspiration in this.[10] But Münster, unlike Folkestone, is and always has been a comfortable middle-class town. Folkestone is only a third of the size of Münster, and is without even a museum at its cultural centre. Because of its ground-breaking venture, Münster has experienced an extraordinary change of image over the past 30 years, from conservative backwater to cultural innovator. We hope that such a paradigm may foreshadow a similar revolution in the perception and fortunes of Folkestone.

10. Münster Skulptur Projekte is the most important international exhibition of art in an urban context; it was initiated by Kasper König and Klaus Bussmann in 1977 and repeated every ten years since. The last exhibition, in 2007, brought together 33 artists and attracted approximately 600,000 visitors. See Brigitte Franzen, Kasper König, Carina Plath (eds), *Sculpture Projects Muenster 07* (Walter König, Köln, 2007).

The Old High Street

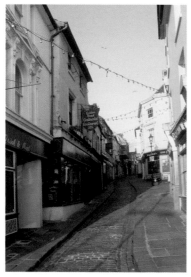

III. THE ARTISTS

The selection of artists for such an ambitious project is obviously crucial. The first Triennial exhibition includes well-known names as well as relative newcomers, working in a variety of media and with widely differing conceptual approaches. However diverse in background, practice or age they might be, they all share a strong record in and affinity for work that engages with community and the life of towns. They are: David Batchelor, Christian Boltanski, Adam Chodzko, Nathan Coley, Tacita Dean, Jeremy Deller, Mark Dion, Tracey Emin, Ayse Erkmen, Šejla Kameric, Robert Kusmirowski, Langlands & Bell, Kaffe Matthews, Ivan & Heather Morison, Nils Norman with Gavin Wade mit Simon & Tom Bloor, Susan Philipsz, Public Works, Patrick Tuttofuoco, Mark Wallinger, Richard Wentworth, Pae White and Richard Wilson.

It was important to include artists with strong roots in the south-east, either by birth or by living and working in the region (Tacita Dean, Tracey Emin, Adam Chodzko, Nils Norman, or Langlands & Bell). Equally significant were formal considerations: those brought together here work in a range of media, from sculpture to installation, performance to sound, and photography to film, demonstrating that art in the street today is no longer the domain of predominantly traditional media. A mix of generations was another consideration: apart from highly acclaimed and experienced practitioners who have an established record of working in the public realm, it was important to introduce younger, emerging artists who were ready to develop a major outdoor commission.

But the most crucial criterion was to choose artists whose multidisciplinary approach enables them to devise community-inclusive, socially engaged projects.

Many of the artworks for the Triennial are collaborative, and have been developed through involvement and discussions with a great number of local organisations – Folkestone People's History Centre, Folkestone and Hythe Operatic and Dramatic Society, H.G.Wells Society, Kent Ornithological Society, local bird and sci-fi enthusiasts, flora and fauna experts, the local mosque, Folkestone Migrant Support Group, teachers and pupils of the Folkestone Academy and many others.

Collaborations such as these are a conceptual cornerstone of the Triennial. They will encourage a grassroots sense of ownership and support across the town's diverse communities. In an economically challenged and socially diverse place such as Folkestone, any artistic intervention into its daily life and public places must be thoughtfully introduced.

IV. THE WORK

Artists were invited in January 2006; site visits, which took place over several months that summer, set important benchmarks and were a first test for the overall concept of the exhibition. Even though Folkestone was *terra incognita* for many of the participants, and not exactly an obvious draw, each reacted with enthusiasm to what they found here. All took inspiration from what they encountered, what they felt was singular about the place. It is perhaps not surprising, therefore, that all proposals appear connected by a strong narrative element, each articulating the past, present and future of Folkestone in new and imaginative ways. Hence the title – 'Tales of Time and Space' – in reference to, but a slight variation of H.G.Wells's book, seemed appropriately to encapsulate the exhibition's message.

Europe's history and its connection to Folkestone is a strong motif played out in the works of Boltanski and Wallinger. Both took the First World War as their cue, notably the fact that more than 1.3 million British and allied soldiers embarked from the town on their journey to France. Research for Christian Boltanski's *The Whispers* resulted in a local appeal to bring to our attention First World War love letters that had been locked away in private collections for decades. Organised together with the

11. There were originally 103 Martello Towers constructed in Britain between 1805 and 1812; five of them are still standing in Folkestone.

Site visit, Tracey Emin, August 2006

Folkestone People's History Society, posters, newspaper advertisements and an open call to join us for drinks and sandwiches at the British Lion for a Boltanski evening yielded a selection of beautiful and moving letters, testaments to love, separation, loss and courage, as well as to the everyday ordinariness of war. It was the artist's wish that these letters be read by local people rather than by actors, thereby completing the circle of local provenance. Mark Wallinger's *Folk Stones* at first appears like an almost banal numbering exercise, a "significant yet pointless act" as he put it, recalling the labour of a modern-day Sisyphus. Yet the precise number of beach pebbles collected and laid out into a massive square reveals a profound underpinning: 19,240 individually numbered stones stand for the exact number of British soldiers killed on 1 July 1916, the first day of the Battle of the Somme. Just as Wallinger's celebrated *State Britain* of 2007 was both tribute to Brian Haw's peace camp and warning against the erosion of civil liberties in Britain, *Folk Stones* is both commemoration and admonition.

The threat of war as well as a notion of fairy tales is conjured up by Ayse Erkmen's *Entangled*. Martello towers[11] were built as defensive structures in anticipation of an invasion by Napoleon. Many of them have been converted into private houses, but Erkmen is highlighting the tower's original military function by shrouding it in a gigantic floral camouflage-net. Made up of thousands of individual plastic flower-shaped objects, designed by Ronan & Erwan Bouroullec in 2004, and fashioned into a gigantic veil, the work speaks as much of war and menace as of Sleeping Beauty and romance.

Vanishing history and its spectral traces are explored in the works of Kusmirowski, Batchelor, Kameric and Wilson. The decline of the fishing industry, so pertinent

Site visit, Richard Wentworth, Mark Dion, July 2006

in Folkestone as well as elsewhere in Britain and Europe, is Robert Kusmirowski's point of departure. Laid out in the once flourishing harbour, his detailed replica fish market, complete with hut, tables, nets and lobster pots, all collected from local detritus, appears like a chimera, only fully visible at low tide, and then to be submerged again at high tide.

The profusion of slowly turning multicoloured spheres of David Batchelor's *Disco Mécanique* recalls the glittering ballrooms and dancing couples of south-coast tourism in its heyday. The spheres, fashioned origami-like from hundreds of cheap plastic sunglasses, display a chromatic brilliance particular to many of Batchelor's works, nourished by synthetic, artificial, chemical, vulgar, industrial, urban colours rather than anything on the organic palette (it is, after all, "Disco" not "Ballet"). Its installation in the historic white-stuccoed grandeur of the Metropole is apposite as well as ironic, as it was here that elegant Edwardians met for their *thé dansant*.

The fact that Folkestone is now undergoing a massive change triggered by the regeneration programme is taken up by Šejla Kameric, Richard Wilson and Nils Norman together with Gavin Wade mit Simon & Tom Bloor. Kameric's stark black-and-white imagery is tinged by *film noir* and her experiences of the four-year violent siege of Sarajevo, her home town. Her large-scale black-and-white posters, as well as her series of framed photographs displayed in socially relevant public buildings, including the working men's club and the police station, weave a melancholy narrative thread through Folkestone's history. Fusing fact and fiction, they become a poetic as well as painful appeal to the collective memory of what was and is no more. The former Rotunda Amusement Park, typical of seaside towns from Blackpool to Coney Island, forms part of her imagery and is also the inspiration for Richard Wilson's *18 Holes*. At the time of writing, the dysfunctional and long overgrown crazy golf course is the only remnant of the otherwise erased park. Wilson's herculean project of cutting, lifting, restoring and reassembling the eighteen weighty concrete slabs around each hole is like a paean to the memory of this former popular tourist attraction.

David Batchelor, work in progress

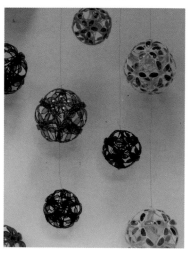

Kite Kiosk by Norman, Wade and the Bloors references the fact that modernist architecture, once flourishing in many British seaside towns including Folkestone, is both quintessence of utopian ideals and early regenerative tool. The kiosk is based on a pavilion designed in the 1930s by Russian émigré architect Berthold Lubetkin, who had viewed architecture as the "embodiment of the social aims of the age". In its contemporary reinterpretation, it includes a critical nod at so many current regeneration strategies through the playful device of coloured kites brandishing slogans appropriated from Marxist theory and regeneration spin.

Folkestone's connection to Europe via boat and train is explored by Tacita Dean, Langlands & Bell and Patrick Tuttofuoco. It seems strangely incongruous that the Orient-Express, most glamorous of trains and epitome of stylish international travel, still pulls in twice weekly at Folkestone. Tuttofuoco has re-enacted the classic journey from Istanbul to Paris and Folkestone (passengers used then to take the ferry from here). Both his film and the sculpture on the harbour arm are the result of his encounters along the way. Like a Debordian *derive*, he allowed himself to drift at each stop of a prescribed route into situations and incidents where his desired letters were to be found, evolving like a serendipitous string of pearls.

Boulogne is only 22 miles away, yet the ferry operates no more between the two towns. In *Amadeus (swell consopio)*, the 16mm film made for the Triennial on a particularly wild and windy day in late March 2008, Tacita Dean takes the viewer across the water again, this time in an old fishing boat, letting us experience a cold dawn as we approach the English coast. Ever since her early film work (such as *Girl Stowaway* of 1994 and *Disappearance at Sea* of 1996), and then later in her blackboard drawings and photogravures, the sea as source of both wonder and disquiet has been a *leitmotif* in Dean's work. The anamorphic (i.e. widescreen) film format underscores the cinematic poetry and epic timelessness of her subject.

The relationship between Folkestone and Boulogne is also explored in a video by Langlands & Bell, but here the artists focus on the people, architecture, street life and customs, rather than on the watery gulf between the two towns. Filmed over many months, it features swimmers at Folkestone's customary Boxing Day Dip, as well as disaffected young rappers at Boulogne's Festival of the Sea singing about unemployment in the declining fishing industry. It is fitting that their work should be screened at the coast watch station (whose elderly volunteer staff become *dramatis personae* in it), as Boulogne is clearly visible from here on fine days.

The generic characteristics of seaside towns are addressed in an apparently light-hearted way by Mark Dion and Jeremy Deller, while the melancholy of such places is touched on by Nathan Coley and Susan Philipsz. Dion's gigantic mobile seagull, complete with resident ornithologist and field guide, might be surreally amusing at first glance, but discloses a serious endeavour through galvanising art and science in an attempt to improve the knowledge and understanding of those who view gulls as only "rats of the sky". The field guide, full of fascinating facts about the diverse gull population of the area, researched, written and illustrated by local enthusiasts in close collaboration with the artist, is an important part of Dion's concept, making this a joint venture that again connects the specific and the general, local and global.

Jeremy Deller has been collaborating with the Folkestone and Hythe Operatic and Dramatic Society on a series of unannounced public performances based on traditional seaside humour and physical comedy, as well as the typically British legacy of Max Wall, Tommy Cooper and Norman Wisdom. Over six months scenarios were developed with a group of amateur performers which, although borrowed from slapstick and comedic genres, should also segue seamlessly into the everyday absurdities of life.

British seaside towns are often associated with retirement and the idea of a "last resort". *Heaven is a Place where Nothing ever Happens*, Nathan Coley's illuminated text sculpture, seen against the sky in Tontine Street, is redolent of this sense of ennui while formally suggesting the expectation of excitement. At once elegant and tacky, the use of white electric lightbulbs evokes 1970s disco glamour as well as fairground aesthetics. Further east, at a look-out affording wide views over the sea, Susan Philipsz' haunting disembodied voice can be heard singing an interpretation of *Dolphins*, made famous by American singer-songwriter Tim Buckley. Her rendition of the song, originally recorded by Buckley in 1973, two years before his death aged 28 of a drug overdose, turns the experience of his melancholy lyrics into a subcutaneous, elegiac lament full of yearning.

Social issues connect the formally disparate works of Tracey Emin, Pae White and Richard Wentworth. Emin's perfect bronze simulacra of baby clothes are tucked under benches, hang from railings and lie by a kerb. Exuding an aura of the forlorn

Jeremy Deller, workshop with members of FHODS, March 2008

and dejected, they are poignant reminders of Folkestone's high teenage pregnancy rates (similar to Margate's, Emin's home town). Fusing poetry and botany, Richard Wentworth's ten-part sign piece, spread across Folkestone's streets, alleyways and avenues, alludes via tree metaphor to the many migrants who disembarked in Folkestone to make their homes here or elsewhere in the country. Like Mark Dion's, this work is an exercise in respect.

Having observed pensioners unable to walk far and stranded on benches, their dogs listless or straining at the lead, Pae White designed her *Barking Rocks* park especially for the needs of both: now the elderly can rest and chat or picnic while their dogs exercise. The site itself, sandwiched between the main shopping street and the marine promenade, had long been neglected and is now transformed into what the artist calls "landscape theatre". Sculptures of cats' heads ominously stuck on nine-foot-high poles are a dramatic (if tongue-in-cheek) warning to those not invited here. *Barking Rocks* is a social sculpture on several counts: it reclaims derelict land, returns it to the community and privileges, in a playful way, the disadvantaged, both human and canine.

Ivan and Heather Morison, work in progress, 2008

Past and future meet in the work of Ivan and Heather Morison and Adam Chodzko. Inspired by Folkestone's famous resident H.G. Wells, the Morisons' mobile science-fiction library is a celebration of this legacy and also an active attempt to nurture new writers in that field. It is functional, participatory and, in its genesis, collaborative with a wide group of people and organisations. Much of the Morisons' work is driven by a preoccupation with utopia, migration, narrative and the natural world. Their own science-fiction novel, *Divine Vessel*, written in 2003 during a four-week

journey on a cargo ship from Shanghai to Auckland, was as much a precursor to 'Tales of Space and Time' as their trip to California in 2007 researching the 1970s nomadic New American Gypsy Movement. Equally influenced by science-fiction (especially by British writers such as J.G.Ballard and John Wyndham), Adam Chodzko has long been interested in collapsing past, present and future to create alternative realities. In a number of film, slide and photographic works he has invented fictitious scenarios, set in a not-too-distant future, that blend the familiar with the strange. Through fantasy, wonder and make-believe, they compel us to reconsider our sense of place and community. In *Pyramid*, Chodzko is keen to puzzle and confound visitors by ensnaring them in a myth he has created in his pseudo-documentary and fake-information sign, both reporting back from a moment in a utopian Folkestone.

Collaboration, participation and interaction are a lateral methodological connection among many of the works. Christian Boltanski's sound piece is heard only when people sit on the bench. The visitor becomes the catalyst and trigger for the work, which is reliant on reaction and engagement. Similarly, *Kite Kiosk*, devised by Nils Norman together with Gavin Wade and the Bloor brothers, is activated and its function fulfilled by its kite-flying public participants.

Having worked with local people and organisations in the research and development of their pieces, Mark Dion, the Morisons and Public Works also act as service-providers for the wider community. The Public Works mobile milk-float hub is the most self-reflexive work of the Triennial. In *FOLKESTONOMY*, direct engagement and consultation with residents throughout the exhibition period will elicit an understanding of their changing sense of "cultural space"; the Public Works enterprise attempts to produce, over time, an important cultural and sociological assessment of the impact on the people of Folkestone of the Triennial in particular and the regeneration programme in general.

The community itself becomes the producer and executor of the work in Jeremy Deller's performative piece, as well as in sound artist Kaffe Matthews's extraordinary *Marvelo Project*. Matthews, a leading figure and pioneer in the field of elec-

Kaffe Matthews, workshop with pupils from Folkestone Academy, March 2008

tronic improvisation and live composition known for her collaborative and multi-disciplinary approach, here initiated a group of eleven year olds from Folkestone's Academy school during a three-week workshop into collaborative composition and sound mapping for a suite of GPS-equipped bicycles. Cycling around the town while tapping into the sounds created by the children and laid out like an audio-net along certain routes, participants become performers and passers-by accidental audience members. It is very much the group who created the *Marvelo Project*: as with Deller's *Risk Assessment*, the artist inspires and facilitates, but leaves much of the creative process to the community protégés. Both Deller's and Matthews's projects are essentially catalysts for social engagement and action.[12]

The development of all the artist proposals, as well as that of their chosen sites, was long and complex. Proposals were researched, budgeted, their feasibility tested, and in some cases, after lengthy processes, rejected as too costly or technically unachievable. We had to part from some fantastic early visions, such as Mark Wallinger's proposal for a gigantic helium balloon in the correct anatomical shape of a human heart, Richard Wilson's crushed *Dracula's Castle*, or Christian Boltanski's heartbeat lighthouse.

It is an extraordinary responsibility as well as a rare challenge to intervene in an urban community and fabric in such a way as this. The genesis of the 22 new works themselves, together with an ambitious, multi-level access and learning programme[13] developed alongside them, demonstrates the Triennial's mission to be an inclusive project that is, as far as feasible, carried through with, by and for the people of Folkestone, yet also reaches out to as wide an audience as possible, from some of the most marginalised groups within the local community to the international art world.

Historically, and thus traditionally, in cultural change and development, the provincial periphery has taken the lead from the metropolitan centre. Now, things may be made to work in both directions. The periphery could perhaps become a model for the centre.

12. See also Claire Doherty, "The New Situationists" in *From Studio to Situation* (Black Dog Publishing, 2004), p.12: "It is vital... to establish the distinction between those practices which, though they employ a process of complicit engagement, are clearly initiated and ultimately directed by the artist... and those which, though still often authored by the artist or team, are collaborative – in effect 'social sculpture'." See also Claire Bishop, *Participation* (MIT Press, 2006).

13. The Triennial's Access and Learning Programme offers not only a wide variety of guided talks and tours, as well as themed workshops for schools and families, but also special workshops and platforms for debate for the local Asian Women's Group, the local Roma community, Age Concern, HomeStart/ Sure Start (teenage mothers and under-fives), ARC (hard to reach youths) and a number of other local youth organisations. An online Learning Resource Pack and a downloadable audio guide will also be made available to provide informed access to 'Tales of Time and Space' to the widest group of people.

ARTISTS

DAVID BATCHELOR
CHRISTIAN BOLTANSKI
ADAM CHODZKO
NATHAN COLEY
TACITA DEAN
JEREMY DELLER
MARK DION
TRACEY EMIN
AYSE ERKMEN
SEJLA KAMERIC
ROBERT KUSMIROWSKI
LANGLANDS & BELL
KAFFE MATTHEWS
HEATHER & IVAN MORISON
NILS NORMAN
 WITH GAVIN WADE
 MIT SIMON & TOM BLOOR
SUSAN PHILIPSZ
PUBLIC WORKS
PATRICK TUTTOFUOCO
MARK WALLINGER
RICHARD WENTWORTH
PAE WHITE
RICHARD WILSON

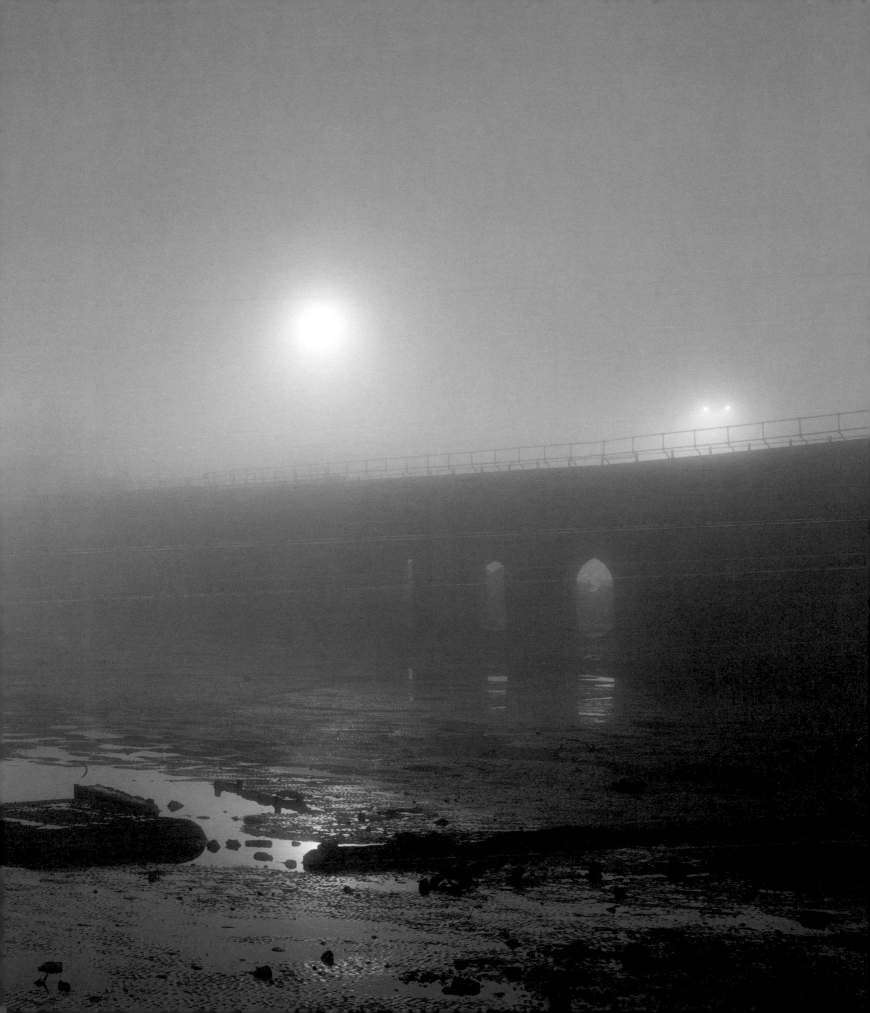

DAVID BATCHELOR

DISCO MÉCANIQUE

Story of the Eyeball

BORN

Dundee, 1955. Lives and works in London.

David Batchelor's art is principally concerned with colour as it is experienced in the modern city, and takes the form of three-dimensional work, works on paper and photographs.

RECENT SOLO EXHIBITIONS

'Unplugged' (Remix), Wilkinson Gallery – London 2007
'Unplugged', Talbot Rice Gallery – Edinburgh 2007
'Festival Remix', South Bank Centre – London 2006
'Ten Silhouettes', Gloucester Road Underground Station – London 2006
'Shiny Dirty', IKON Gallery – Birmingham 2004

RECENT GROUP EXHIBITIONS

'Color Chart', MoMA – New York 2008
'Echo Room', Alcala 31 – Madrid 2007
'Abstraction', Millennium Galleries – Sheffield 2007
'Backdrop', Bloomberg Space – London 2006
26th Biennale de São Paulo – Brazil 2004

Batchelor is the author of Minimalism (1997), Chromophobia (2000) and editor of Colour (2008). He is currently Senior Tutor in Critical Theory at the Royal College of Art, London.

ACKNOWLEDGEMENTS

Andrew Everett, Fernanda Figueiredo, Joana Gauer, Tim Holmes, Eduardo Leme, Isabel Ralston, Lora Rempel, Eduarda de Souza, Amanda Wilkinson, Anthony Wilkinson.

Herman Melville described colour as a "mystical cosmetic"; it was something attached to the world but only loosely, like make-up. It made the world, literally, easier on the eye. But this make-up wasn't merely superficial or deceitful or simply for pleasure, it was necessary because, Melville speculated, without colour we would be blinded by the fierce white light of naked existence. To describe this condition he used the metaphor of an arctic explorer who, without "coloured or colouring glasses", would quickly be rendered snow-blind. Colour enables us to see what would otherwise destroy us, Melville thought, as he contemplated the great monstrous whiteness of *Moby Dick*.

To be honest, I wasn't thinking about Herman Melville when I found these sunglasses in a street market in São Paulo; I was looking for cheap, brightly coloured plastic objects that I might be able to use somehow. After some time I discovered 30 pairs of glasses could be joined together to form almost regular spheres.

For many years much of my work tended towards the rectangular and box-like; now some of it has become more circular and spherical. I'm not sure why. I don't mean ideal platonic forms or the pure geometry of the Bauhaus, but rather the opposite: damaged forms and found objects; dirty rectangles, imperfect spheres, deflated globes, lost balls.

The eye is perhaps one of the most resonant of actual spheres, one always available to map on to other spheres: any ball, disc or circle can be made into an eye, with the help of a marker pen or a little imagination. These balls of eye-wear are also eyeballs, if only just.

The eye is sensitive, above all, to colour. According to some theories of vision, all we actually see is patches of coloured light. The rest, the organisation of perception into space, objects and concepts, is done in the brain. A part of the aim of this work is to return these objects to patches of coloured light. Its aims are optical rather than spectacle.

Where better to show some balls than in a ballroom? Fernand Léger made his short film *Ballet Mécanique* in 1924, a black-and-white film by an artist with a great love for the city and for colour. *Disco Mécanique* is the product of similar interests; it is also (almost) my first movie, although a sculptural movie rather than a filmic one.

Opposite:
Disco Mécanique, plastic sunglasses, mirrorball motors, fishing line, aluminium, 4 × 6 × 3.75m, 2008

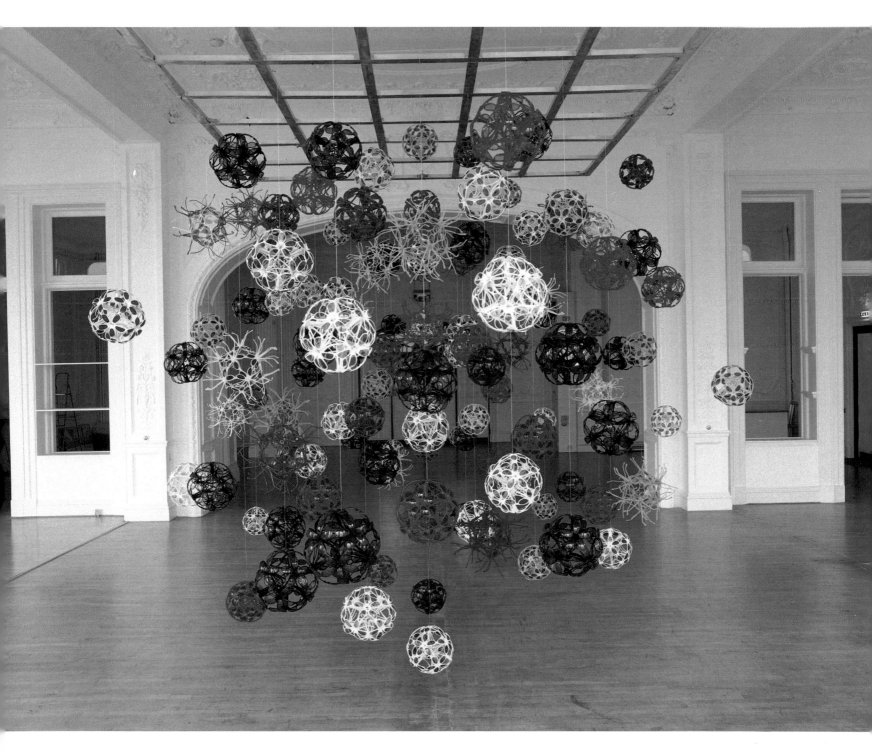

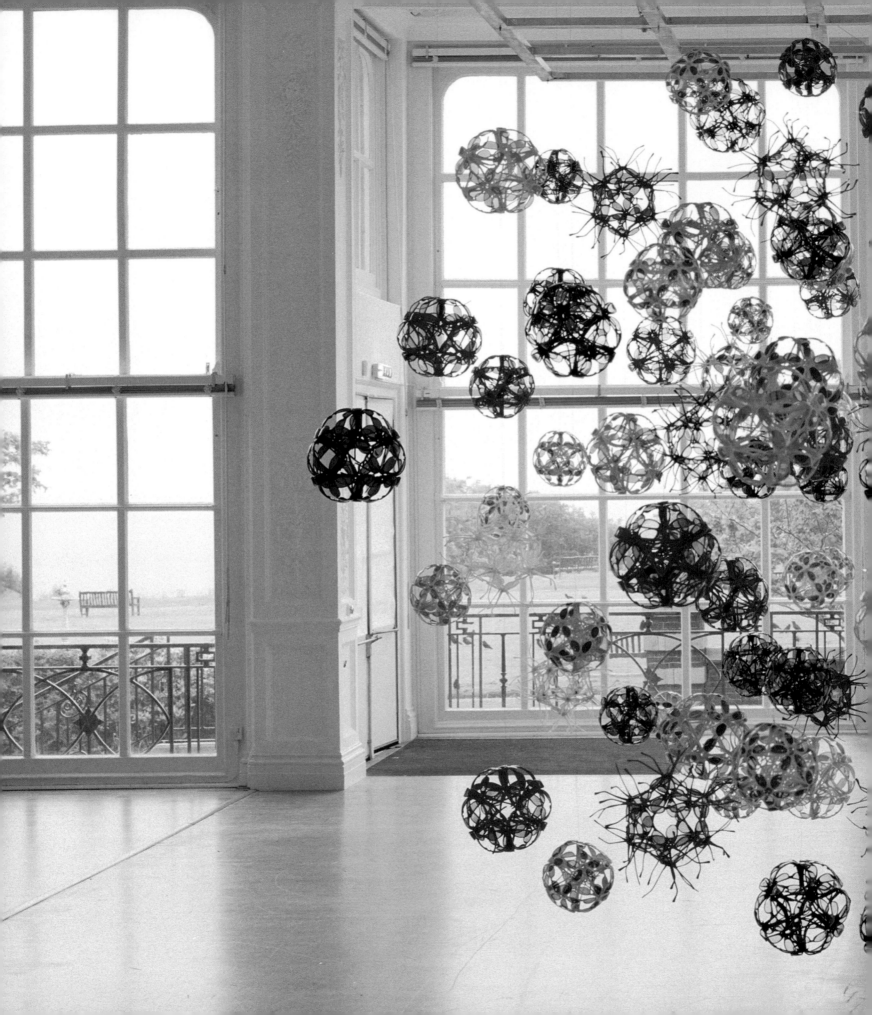

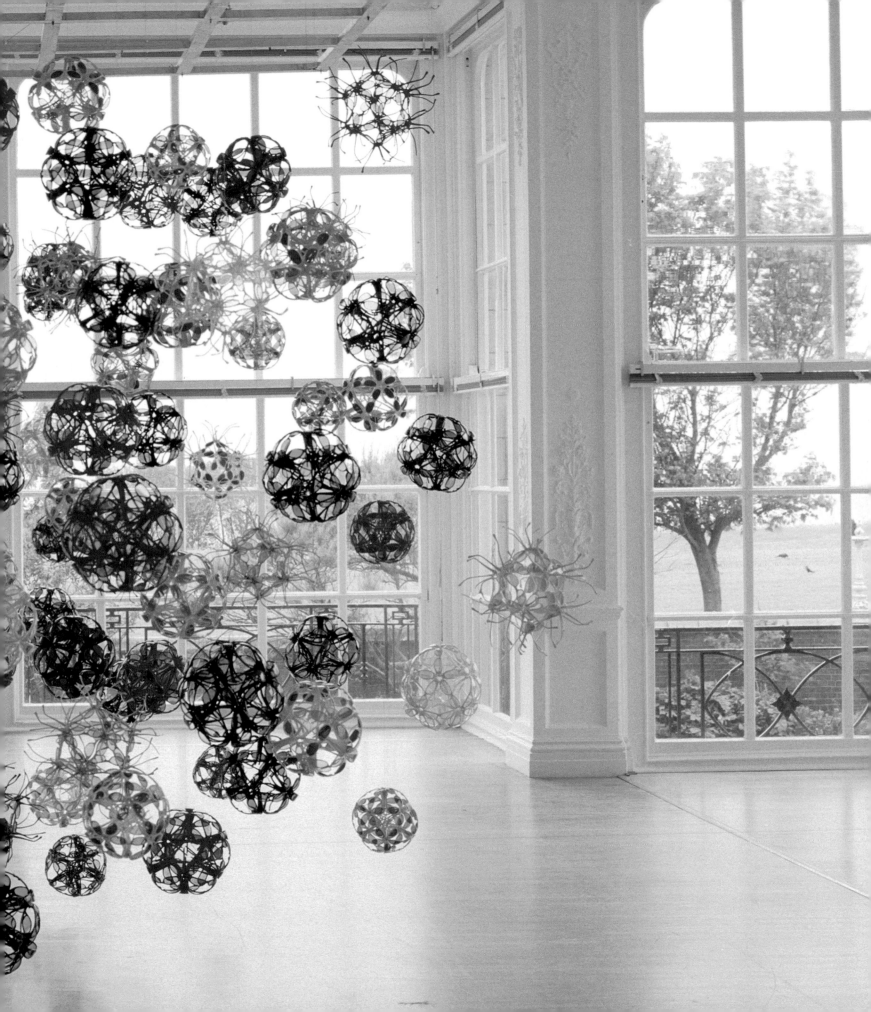

CHRISTIAN BOLTANSKI

THE WHISPERS

Folkestone is full of ghosts. Over time its shores have witnessed the arrival and departure of many people. It has been a place of transition and a site that has borne witness to much activity; from the departure of troops for the front line to the loss inflicted by war that was endured by those who remained.

The Whispers is about love, longing and loss derived from letters written during the First World War. The voices in *The Whispers* quietly speak the words written by those stationed in Folkestone and those who had already departed for the battlefields. We listen to the letters of those who wrote in remembrance of their loved ones at home in Folkestone and elsewhere in England.

Folkestone marks a point from which we can remember the love that was lost. Many people have looked out to sea from The Leas and tried to imagine those they had to leave. To me the sea becomes a wall which is impossible to cross. It is infinite, has unknown depths and takes the traveller away from what is familiar. It represents a literal and metaphorical barrier between those who left and those who remained. It is impossible to know the fate of loved ones on the other side. They dreamt and they hoped. We hear these hopes and dreams in the voices of *The Whispers*.

Opposite:
The Whispers, recording, Folkestone, March 2008

Overleaf:
Site for *The Whispers*, four-part audio installation, 2008

BORN

France, 1944. Lives and works in Paris.

Christian Boltanski works with the ephemera of the human experience, dealing with questions of death, memory and loss. Known for a body of work that may be considered an archive of our social, cultural, ethnic and personal histories, he is one of France's most widely exhibited living artists

RECENT SOLO EXHIBITIONS

La Maison Rouge – Paris 2008
Magasin 3 – Stockholm, Sweden 2008
'Christian Boltanski – 6 septembres', Marian Goodman Gallery – New York 2007
'Christian Boltanski Zeit', Mathildenhöhe – Darmstadt, Germany 2006-2007;
Museo d'Arte Contemporanea – Rome 2006
A.V.Schusev State Museum of Architecture – Moscow 2005
Marian Goodman Gallery – Paris 2005
MACRO Museum of Fine Arts – Boston 2000
Haus der Kunst – Munich 1997

RECENT GROUP EXHIBITIONS

Christian Boltanski has participated in numerous group shows as well as in the Venice Biennale, 1972, 1980, 1986, 1993, 1995 and Documenta, Kassel, Germany, 1972, 1977, 1987

In 2006 Boltanski was awarded the Laureate of the Praemium Imperiale, and in 2001 won the Kaiser Ring, Mochhausmuseum Goslar and the Kunstpreis, given by Nord/LB, Braunschweig, Germany.

ACKNOWLEDGEMENTS

Oliver Cragg at Hidden Track Studios, Mike Blow at Evolutionary Arts, Olivia Wilkes, Tom Clampitt, Tom Heselden, James Durkin, Paula Durkin, Anne Mortimer at FHODS, Charles Fair, Stephanie Fair, Dr Lesley Hardy and her team at the Folkestone People's History Centre.

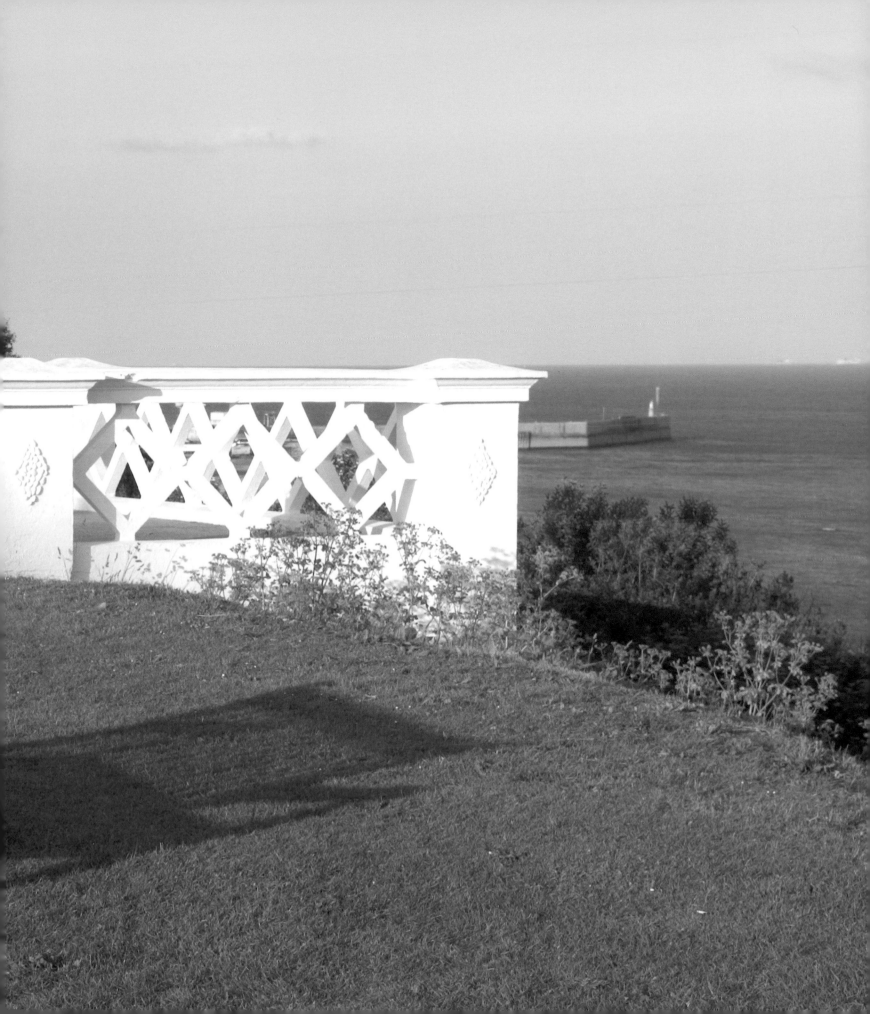

ADAM CHODZKO

PYRAMID

BORN

UK, 1965. Lives and works in Whitstable, Kent.

Adam Chodzko's art proposes new relationships between our value and belief systems, between the communities and private spaces that generate these systems, and between the documents and fictions that describe and guide them. Since 1991 he has exhibited extensively in international solo and group shows.

RECENT SOLO EXHIBITIONS

Tate St Ives – England 2008
Dublin City Art Gallery – Ireland 2007
MAMbo – Bologna 2007
Signal – Malmo, Sweden 2007
Cubitt – London 2002

RECENT GROUP EXHIBITIONS

'Breaking Step', Museum of Contemporary Art – Belgrade 2007
'One Brief Moment', apexart – New York 2006
British Art Show 6 – Newcastle (touring) 2005/2006

In 2007 Chodzko was offered a three-year AHRC Creative Arts Fellowship with the University of Kent and in 2002 he received awards from the Paul Hamlyn Foundation and the Foundation for Contemporary Art, NY, USA.

FILM ACKNOWLEDGEMENTS

Drummers: Tim Knight, Tom Marshallsay, Tim Rowan, Greg de Pulford, Robert Read. Children: Seth, Clay, Lili, Charlie, Adam, Isaac, Tiernan, Jo Louie, Saul, Harvey, Jayden, Jo, Ella, Maxi, Zoe. Producer: Catherine Herbert. Assistance: Polly Read. Sound design: Justin Chodzko. Sound engineering: Tim Barker. Editing: Marcus Korhoren. Make-up: Niky Buckland. Jim Body at ArjoWiggins Chartham Ltd, Howard Cocker at Church and Dwight Ltd, Stephen Levine, Pat Seggery and all at the Leas Cliff Hall, BBC South East.

Looking back at The Leas cliff from the tip of the longest rock jetty in front of it, you can see a thick horizontal canopy of trees. Although you don't really see the trees. Instead, what you see is the hole, the puncture mark made by the projecting balcony of the Leas Cliff Hall, like a wound from a splinter. Close up, underneath this structure, is a stark space which feels as though it shouldn't be there, hovering instead from another time and space. Like those chambers of abrupt angles glimpsed under flyover bridges as you drive along a motorway; back-stage space (the shallow "real" space left over from supporting an illusion), the start of an Inca temple, the entrance to a nuclear bunker, the legs of a pylon, cathedral buttress, section of spaceship... *big things*! I normally stay clear of pumped-up art objects, but staring into this odd void I felt like making a grotesquely large sculpture. But to do this without any materials and to build it using the structure of a half-sleep state.

Leas Cliff Hall above is a large concert hall. Metallica and Roy Chubby Brown play there, separately. Under its overhang is a condensed amalgamation of architectural motifs, like the storage at the back of a Cecil B. DeMille film set; classical columns, a wooden stockade and, most strikingly, the steel skeletons of four enormous pyramids. Ominously, the pyramids are facing downwards. Bad luck. The town's fortunes had been declining and on 28 April 2007 it suffered an earthquake. I was wondering what this town collectively dreams at night.

I like the idea of artworks that become so lugubrious with significance that they collapse. And too the notion that the destruction of a relationship in the future would somehow send out fragments into the present; tangible ruins having emanated from a fantasy about what happens *next*. Can you get ghosts entering the present from the future?

There's nothing really there. So I make a video that records an hallucinatory ritual that the town performs to lift the curse of the pyramid inversion. The pyramids need acknowledging; building out of a fantastic material, then inverting so that they point skyward, then celebrating this through a concert in the concert hall above, and then destroying it all, dragging the pyramids' remains out to sea so that nothing is left. But all this could not occur without some kind of trace, and there remains, beyond the video, a sign that indicates the marks in the landscape from this "party"; the remains of some glue, a twisted stone pine, a shattered rock... a few scars.

So there's nothing really there afterwards (or is it before?), apart from a misinterpretation panel. And perhaps a rumour growing, gossip that gets passed on about what happened in this place. Everything else is just a support structure for this myth.

Opposite:
Pyramid 2008, interpretation panel (detail)

Overleaf:
Pyramid 2008, interpretation panel in situ, brushed stainless steel, 63.5 × 90cm

Pyramid 2008, production stills from video installation with sound, 12 mins
(photo: Catherine Herbert)

Pyramids

A rumour grew in Folkestone that the town's misfortunes were caused by the four inverted pyramids that support the overhang of the Leas Cliff Hall. Therefore, an event was created that would thwart the bad energy that was perceived to be emanating from these structures. The pyramids were completed, their frames clad in a brilliant material, and an illusion devised so that they now pointed towards the sky. In order to complete the lifting of the curse these 'corrected' pyramids were then ritualistically destroyed and dragged out to sea. Apart from their original framework little evidence of this incident remains, other than the traces indicated here.

Material from the internal structure of the pyramids covers the top of the previously grassy bank.

A stone pine twisted by the falling façade of pyramid 1.

The remains of the adhesive used to secure enormous mirrored panels to the underside of the overhang.

A sandstone rock shattered by the dragging of the façade of pyramid 2 towards the beach.

Traces of the original pathways to the pyramids can still be seen in winter.

The piers of the small wooden bridge leading to the beach still show the impact of the façade of pyramid 4 as it was pushed out to sea.

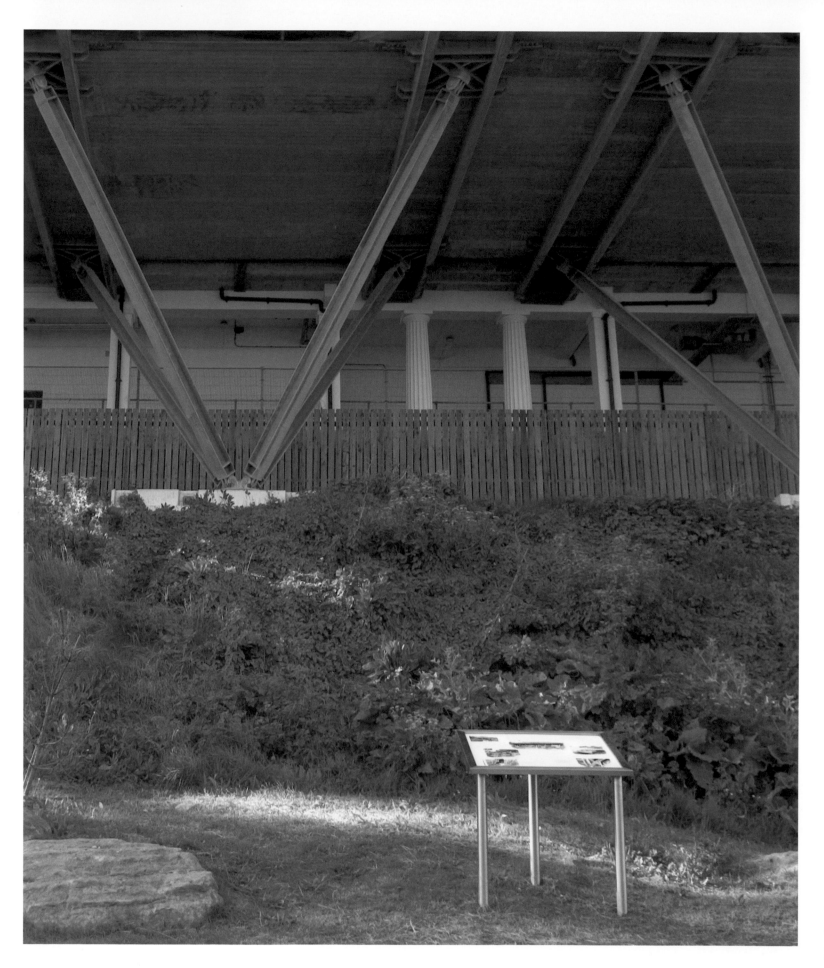

NATHAN COLEY

HEAVEN IS A PLACE WHERE NOTHING EVER HAPPENS

Heaven (hev-*uh* n) *n* 1 (*sometimes cap.*) *Christianity.* **1.** the abode of God, the angels, and the spirits of the righteous after death; the place or state of existence of the blessed after the mortal life. **2.** (*initial capital letter*) Often, **Heavens**. the celestial powers; God. **3.** a metonym for God (used in expressions of emphasis, surprise, etc.): *For heaven's sake!* **4.** **Heavens** (used interjectionally to express emphasis, surprise, etc.): *Heavens, what a cold room.* **5.** Usually, **heavens**. the sky, firmament, or expanse of space surrounding the earth. **6.** a place or state of supreme happiness: *She made his life a heaven on earth.*

Stairway to Heaven is a song by the British rock band Led Zeppelin composed by guitarist Jimmy Page and vocalist Robert Plant and recorded on their fourth studio album (*Led Zeppelin IV*). It is the most requested and most played song on FM radio stations in the United States, despite never having been released as a single there. In November 2007, through download sales promoting their recent *Mothership* release, the song hit #37 on the UK Singles Chart and #13 on the New Zealand Singles Chart. In 1982 a prominent US Baptist claimed that the song (when played in reverse) contains Satanic references. This so-called "Backmasking" was discussed at a hearing of the Consumer Protection and Toxic Materials Committee of the California State Assembly into popular music, where the song was played as evidence. Led Zeppelin for the most part have ignored such claims; for years the only comment came from Swan Song Records, which issued the statement: "Our turntables only play in one direction – forwards."

Heaven is a wooden roof or canopy over the outer stage of an Elizabethan theatre.

Heaven is a film directed by Tom Tykwer, starring Cate Blanchett and Giovanni Ribisi. A woman takes the law into her own hands after police ignore her pleas to arrest the man responsible for her husband's death, and finds herself not only under arrest for murder, but falling in love with an officer. At roughly an hour and a half, *Heaven* is a cinematic triumph that nudges open the gates to the philosophy and psychology of the lone man or woman, along with those of society on the whole. It takes place in Italy, but Tykwer himself stated in an interview that really it could have been shot in any number of places with the message remaining the same. *Heaven* is a thinly-scripted, in-depth commentary on issues prevailing throughout the modern world. Drugs, sex, sexuality, identity and the fibres that make up humans as a race are what this film revolves around: it is not a film for tourists or spectators. First released in 2002, duration 97 minutes.

Heaven is clean fresh cotton sheets on a large comfortable bed.

Heaven is a famous gay nightclub in Villiers Street in London. It first opened its doors in the mid-1980s. Club nights include "**popcorn**", "**WORK!**", "**Heaven Saturday**" and "**HardHouseHeaven**": "London is fortunate to have all its options, but nothing quite matches Heaven's endurance, size or variety." Getting into Heaven is best accomplished by buying a ticket online in advance – www.heaven-london.com/london.

Heaven is a farm in the heart of Sussex Weald where time stood still. It celebrates 170 years of farming life throughout the year, catering for all visitors including groups and coach parties – www.heavenfarm.co.uk.

Opposite:
Heaven Is A Place Where Nothing Ever Happens, scaffolding and illuminated text, dimensions variable, 2008

BORN

Glasgow, 1967. Lives and works in Glasgow.

Nathan Coley's practice is based on an interest in public space and explores how architecture comes to be invested, and reinvested, with meaning. He works in a diverse range of media including public and gallery-based sculpture, photography, drawing and video.

RECENT SOLO EXHIBITIONS

Haunch of Venison Gallery – Berlin 2008
Doggerfisher Gallery – Edinburgh 2007
'We Must Cultivate Our Garden', Public Art Project – Edinburgh 2007
'There Will Be No Miracles Here', Mount Stuart – Isle of Bute, Scotland 2006
'Gathering of Strangers', ICA – Nottingham 2006

RECENT GROUP EXHIBITIONS

'Breaking Step', Museum of Contemporary Art – Belgrade 2007
British Art Show 6 – Newcastle (touring) 2005/2006
'Solitude', Upstairs – Berlin 2006
'A Cidade Interpretada', Santiago de Compostela – Spain 2006

Coley was nominated for the Turner Prize 2007 and awarded the Artist Award from the Scottish Arts Council in 2003 and 1996.

ACKNOWLEDGEMENTS

Stephanie Camu, Susanna Beaumont, Katrina Brown, Andy McGeorge, Brian Johnstone, Haunch of Venison Gallery, doggerfisher.

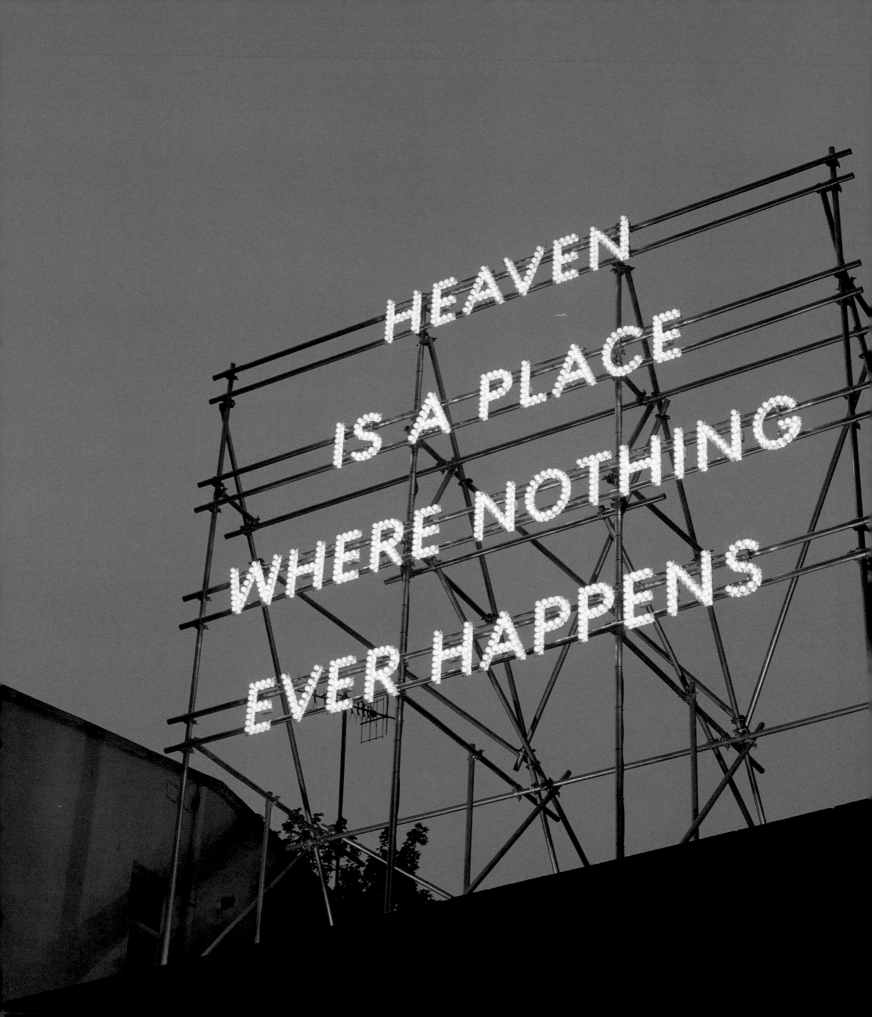

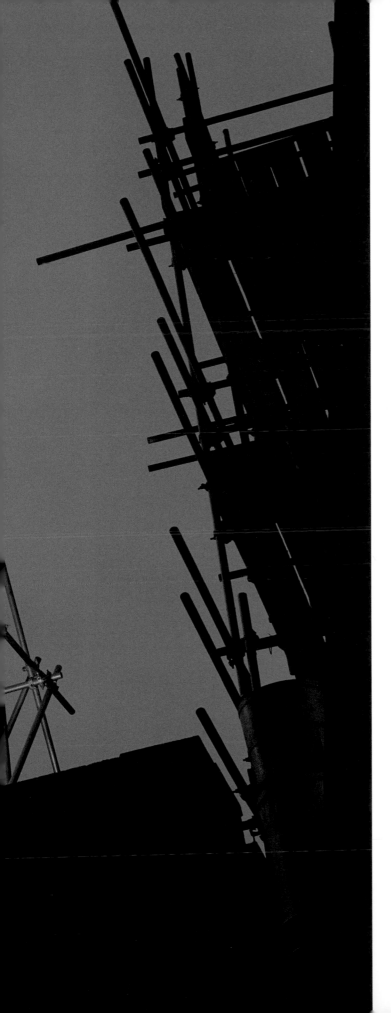

BORN

Canterbury, 1965. Lives and works in Berlin.

Tacita Dean trained as a painter and now works in a variety of media. She is best known for her 16mm films in which issues of time and film-making are of central importance.

RECENT SOLO EXHIBITIONS

Guggenheim Museum – New York 2007
The Hugh Lane Gallery – Dublin 2007
Miami Art Central – Florida 2007
Schaulager – Munchenstein 2006

RECENT GROUP EXHIBITIONS

'On History' – Madrid 2007
'Universal Experience', MART Rovero –
Italy 2006
4th Berlin Biennial for Contemporary Art –
Germany 2006
'Universal Experience', Hayward Gallery –
London 2005
51st Venice Biennale – Italy 2005

Dean has received many awards, including the 2006 Hugo Boss Prize and the DAAD Fellowship. In 1998 she was shortlisted for the Turner Prize.

ACKNOWLEDGEMENTS

Jan Rudolph, John Bayliss, Shirley Sheridan, James Pearson, Ellie Thomson and Karin Backlog at Folkestone Library.

With special thanks to: Steve Felton, Keith Collins, Emma Astner, Mathew Hale, Brian Oxley, Joseph & Jenefer Dean, Kenneth Graham, Simeon Corless, Dale McFarland, Frith Street Gallery, London and Marian Goodman Gallery, New York/Paris

FILM ACKNOWLEDGEMENTS

Director of Photography: John Adderley
Camera Operators: Jamie Cairney;
Sara Deane
Clapper Loader: Sara Deane
Production Assistant: Peter Fillingham
Skipper and Crew of Amadeus: Luke Hodges, and Mick Varnish, Ted Marsh, Steve Magna
Drivers: Angela Adderley; Rachael Daniels
Neg Cut: Reelskill
Printed by: Soho Images, with thanks to Len Thornton
Originated on: Kodak Motion Picture Film

Commissioned by the Creative Foundation for the Folkestone Triennial 2008
Filmed on location in The English Channel

TACITA DEAN

AMADEUS (SWELL CONSOPIO)

I learned to swim in Folkestone, not in the sea but in the public swimming pool. Apart from this, I have only a few memories of going there, except to leave it by ferry on daytrips to Boulogne. I have only known one family home, which is ten miles or so from Folkestone as the crow flies. To be invited to make a work of art for the Triennial has meant an uncomfortable collision of the two distinctly separate parts of my life, delineated quite clearly in my head by my departure from Kent.

At first, I was bemused by the prospect of a Triennial in Folkestone, because it seemed so improbable, but I agreed to take part, seeing it as a chance to bring the second part of my life to meet the first, or invest some of the first into the second. I travelled the Romney Marshes and the towns and landscape surrounding Folkestone, the pebbled coastline and the decaying hinterland in search of a subject that could, in its essence, sum up the complexities of everything I felt about this place. I met and discussed it with people I'd known for years, perused old books and postcards in search of anything that could trigger an idea. Although I recognised everything, it was always disproportionately emotional, because I recalled it all in a childhood way. This familiarity, like the wily beast it is, led me down one nostalgic cul-de-sac after another. My recidivist failure to find an idea reached its apotheosis in February when I received a postcard from my mother, which read just this: "Idea. Go back to square one: Google – Folkestone. Don't try to be too clever or subtle."

So I did what many have done when they have troubles on land: I took to the sea. Folkestone is all about its relationship to France and the water in between – the Martello towers, the Royal Military Canal, the acoustic mirrors, the deserted ferry terminal and Channel Tunnel rail link. For centuries, we have been barricading ourselves in or trying to reach across. The Channel is our local history: we have fished it, reclaimed land from it, smuggled across it, tried to keep it out or traversed it to lands beyond. We are an island people who have become too content with looking in and have let our seaport citadels rot. I have left England and to return is to return by sea. I might have set myself up badly as a prodigal, choosing a choppy inhospitable sea to cross, which incapacitated my nauseous crew into a Gustav Doré tableau, but I did as all Kentish people should do: I suffered the sea to get home.

Opposite:
Swell Consopio (diptych), colour photographs, 2008, 86 × 130cm each

Overleaf:
Film stills from *Amadeus (swell consopio)*, 2008, 16mm colour anamorphic film, mute, 50 minutes

JEREMY DELLER

RISK ASSESSMENT

BORN

London, 1966. Lives and works London.

RECENT PROJECTS

'Marlon Brando, Pocahontas, and Me', Aspen
Art Museum – Colorado 2008
4th plinth shortlist exhibition, The National
Gallery – London 2008
Bat House Project, a competition to design a
bat house – London 2007
Tube Map cover design with Paul Ryan –
London 2007
'You're rendering that scaffolding dangerous',
Kunstverein – Munich 2006
Our Hobby is Depeche Mode, a documentary
film co-directed with Nicholas Abrahams, 2006

RECENT GROUP EXHIBITIONS

Sydney Biennale – Australia 2008
Sculpture Projects – Münster 2007
Carnegie International, Carnegie Museum of
Art – Pittsburgh 2004-2005
Manifesta 5 – San Sebastian 2004

ACKNOWLEDGEMENTS

Sue Blakesley, Danielle Blyde, Caroline
Dowling, Paula Durkin, James Durkin,
Nicholette Goff, Natalie Hubbard, Emma
Moody-Smith, Anne Mortimer and Mitch
Mitchelson. Inspiration for the work: Stan
Laurel, Oliver Hardy, Jacques Tati and
Charles Hawtrey.

Every day during the Triennial, locals will perform
small slapstick routines around the town. They will
be comedic interventions that will hopefully be an
almost invisible addition to the daily workings of
Folkestone.

This is a performance piece that can work any-
where, but by the seaside it takes on an extra di-
mension. The seaside is a place with many comedic
associations, from saucy postcards, end-of-the-pier
humour, carry-ons, to Monsieur Hulot. Rules
are slightly relaxed at the seaside. There is often
a more carefree atmosphere, in which we are not
quite ourselves.

Opposite:
Laurel and Hardy, film still from *Liberty*, 1929,
Hal Roach / Kobal collection

Overleaf:
Jacques Tati, film still from *Vacances de M.Hulot*,
1953, Cady film / Specta films / RGA
Max Wall, 1974, Rex Features

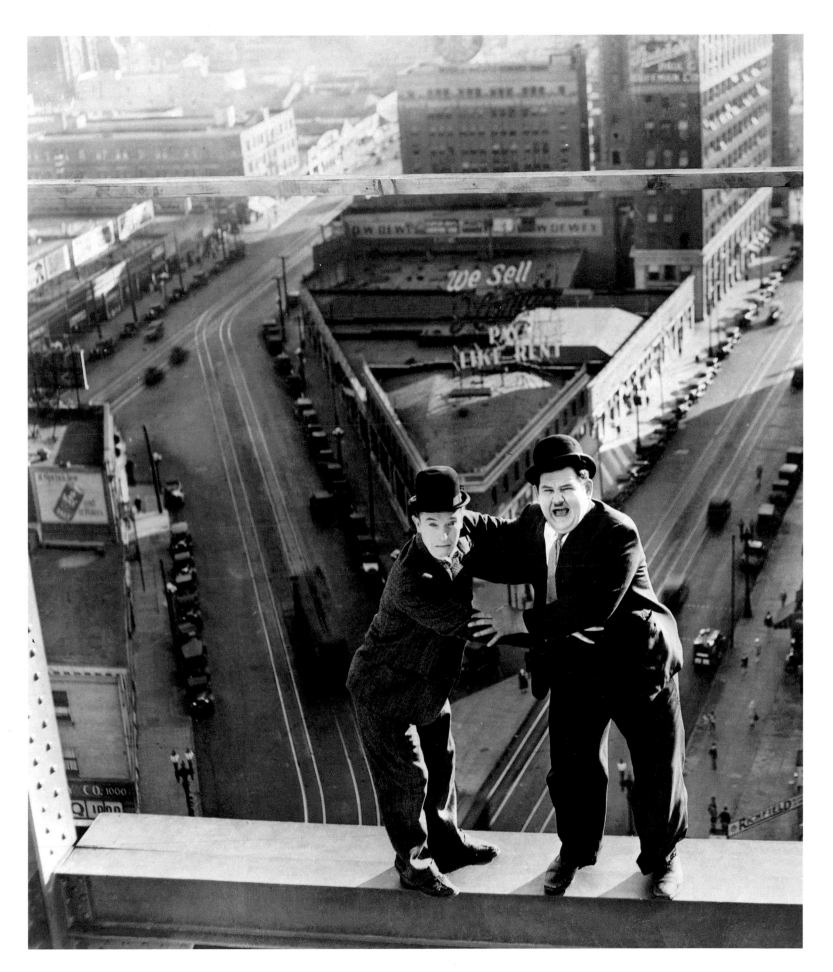

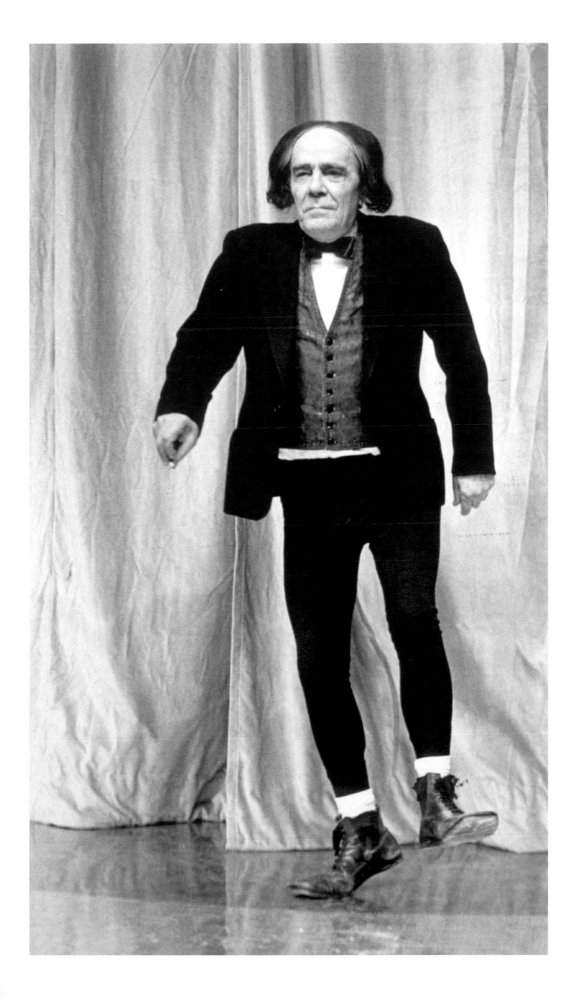

MARK DION

MOBILE GULL APPRECIATION UNIT

Of Gulls and Men

On arrival in Folkestone I was greeted by the sounds and sights of working boats in the harbour and the smell of salt on the stiff breeze, and while this stimulated a vague familiarity, it was the cry of the gulls which invoked in me a deep nostalgia for the coastal haunts of my childhood in Massachusetts. The presence of gulls can stir the blood.

Folkestone is a town inhabited by two distinct and conspicuous populations of highly social, resourceful and resilient beings: the humans and the gulls. Increasingly, we are bound to gulls in a form of symbiosis known as inquilinism. Sharing attributes of both parasitism and commensalism, inquilinism describes organisms which live habitually in the abode of other creatures that construct habitats. Inquilines share our "nest" without providing us benefit or doing us harm. Many gulls have been able to adapt to humanised disrupted environments, exploiting our spaces as sites of increased food supply and novel nesting opportunities. Gulls are specialists at non-specialisation, and thus have been able to respond to our altering of their traditional breeding ground and drastically compromising their natural food sources with surprising flexibility. Perhaps this is due to the fact that these birds are extraordinarily diversely distributed and exhibit a cosmopolitan range of living solutions for which they are well equipped as animals which swim, walk and take to the air with wonderful agility.

While human societies and gull societies live side-by-side, the coexistence is far from an equitable one. Very little that gulls do can change our behaviour or affect our existence, yet human actions dramatically impact on gull populations. Our patterns of recreation, development, waste disposal and particularly ocean harvesting have altered gull behaviour, often bringing them into closer contact with civilisation. This proximity has resulted in animosity. Some people frankly fear and despise the birds, viewing them as unsanitary pests akin to the brown rat.

My team of gull enthusiasts and I contend that rather than a nuisance, gulls are in fact very cool. As in the case of most prejudice, hostility towards gulls is born from misunderstanding rooted in ignorance. Yet gulls are one of the most behaviourally analysed wild animals on the globe, and thus through a brief introduction to gull research and some patient, or at least tolerant, observation, it is quite possible to know them intimately. Of course we are far from a complete understanding of gull society, and any student of animal behaviour realises that the more we comprehend of the animal mind, the more we are humbled by how little we actually know. Naturalists find this challenging and exhilarating. Still, we have since the 1920s accumulated a vast amount of knowledge regarding the ways of gulls. This information can allow us, in an almost Dr. Doolittle manner, to comprehend gull communications by training ourselves to see and interpret postures and movements and hear and discern vocalisations. Gulls are a highly social species and thus the actions and sounds produced by individuals can be "understood" by others in the group. Through some training we can indeed recognise and interpret aspects of gull speech.

The Mobile Gull Appreciation Unit and its accompanying publications are mandated to advocate an affection for gulls beyond merely their inherent beauty and remarkable ability. Through an introduction to the ornithological and behavioural literature, visitors to the Mobile Gull Appreciation Unit can value gulls through better understanding, for to know gulls is to love them.

I do not subscribe to the romantic notion that beauty dwindles as science and knowledge gains. Understanding phenomena through research, observation, experimentation and representation, far from stripping value, motivates a deeper and awesome appreciation of the wonders of the natural world. Art and science, far from being in mortal combat, are often targeted on the same goal, however they employ radically distinct tools and methods. The Mobile Gull Appreciation Unit amalgamates art, science and amateur enthusiasm to encourage the people of Folkestone and its numerous visitors to enrich their lives by getting to know better their fascinating neighbours.

Opposite:
Mobile Gull Appreciation Unit, fibreglass and steel structure, books, signage, and mixed media 2 × 4.8 × 3m, 2008

BORN

New Bedford, Massachusetts, USA, 1961. Lives in New York City and works worldwide.

Mark Dion's artwork incorporates aspects of archaeology, ecology, detection and systems of classification by which people have tried to bring order to the world.

RECENT SOLO EXHIBITIONS

'Systema Metropolis', Natural History Museum – London 2007
Carré D'Art, Nîmes – France 2007
Miami Art Museum – Florida 2006
The Academy of Fine Arts – Vienna 2004
Yerba Buena Centre for the Arts – San Francisco 1998

RECENT GROUP EXHIBITIONS

'Surrealism and Beyond', Israel Museum – Jerusalem 2007
'Drawing from the Modern', MoMA – New York 2005
Sculpture Projects – Münster 1997

Dion was awarded the Larry Aldrich Foundation Award in 2001 and the Joan Mitchell Foundation Award in 2006. He received an honorary doctorate of arts degree from the University of Hartford in 2003.

ACKNOWLEDGEMENTS

Jane Burden at Nebulo Strata, Sara de Bondt and Gregory Ambos, Kent Ornithology Society, with particular thanks to Martin Coath, Ian Roberts and Phil Lightman, Katie Day, Jessica Doyle, Benjamin Fletcher, Darren Fletcher, Victoria Foster, Mark Heywood, Stephanie Hosmer, Marco Palmieri, Jack Sandwich and Emily Wallis, Martin Coath.

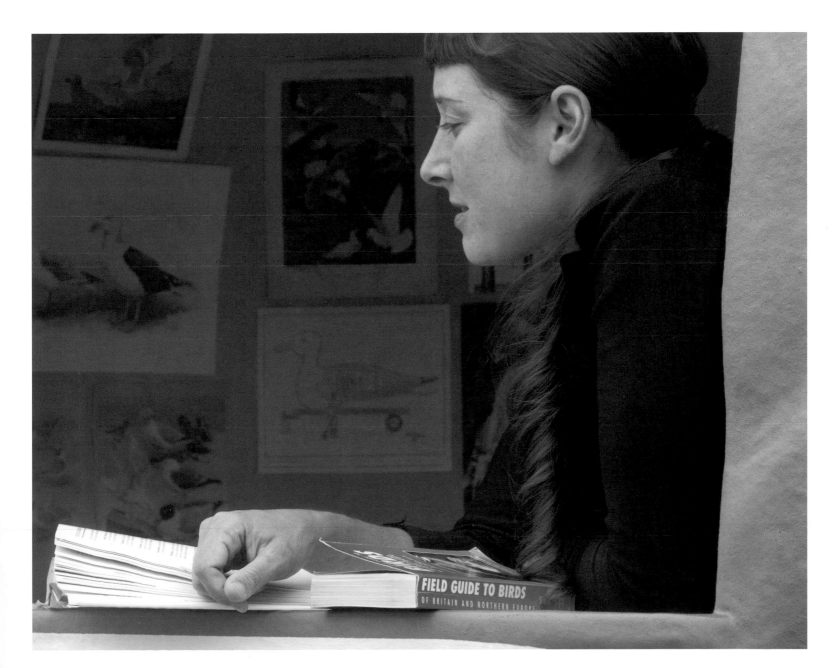

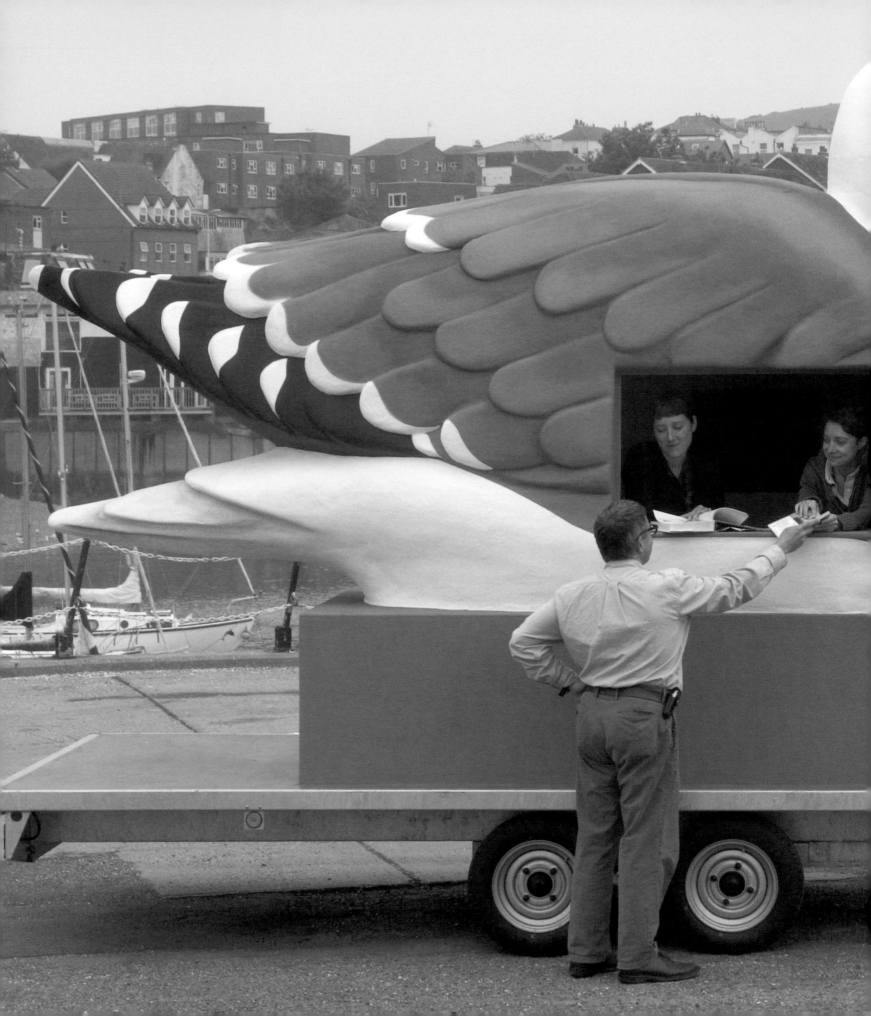

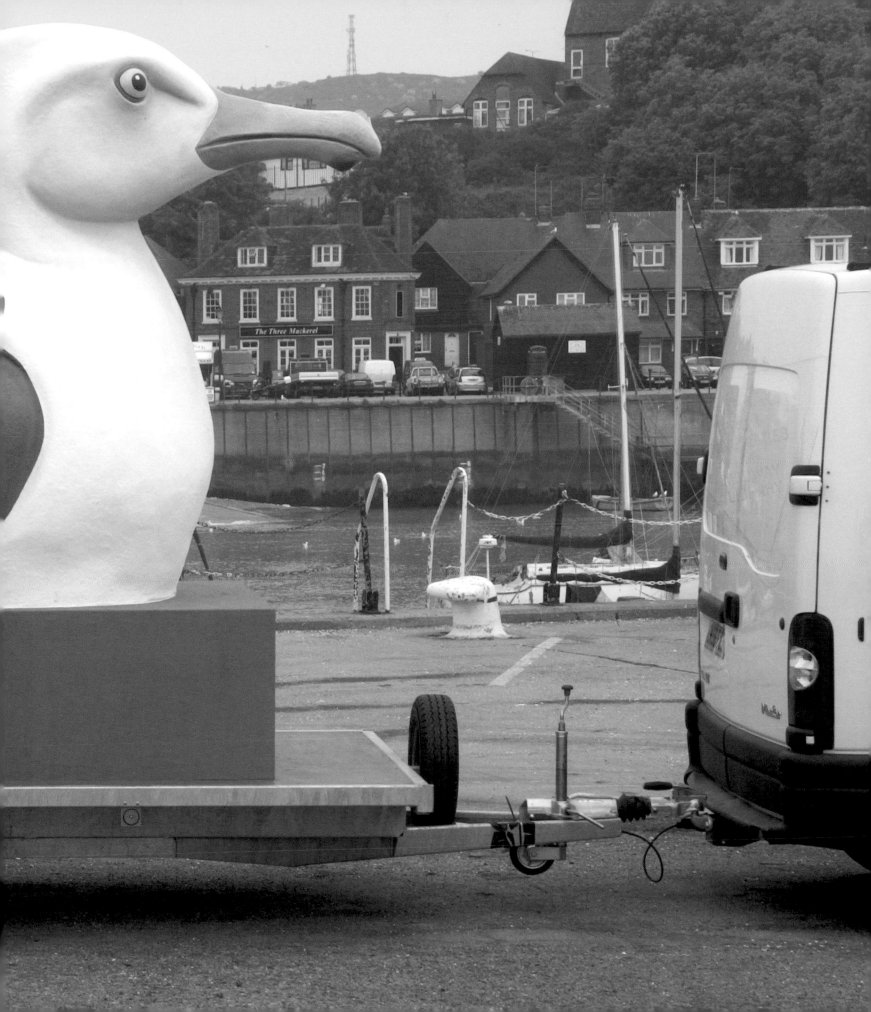

TRACEY EMIN

BABY THINGS

BORN

London, 1963. Lives and works in London.

Tracey Emin's art is one of candid
disclosure, using events from her own life
as inspiration for her practice, ranging from
painting, drawing, video and installation to
photography, needlework and sculpture.

RECENT SOLO EXHIBITIONS

British Pavilion, 52nd Venice Biennale – Italy
2007
'More Flow', Galleria Lorcan O'Neill –
Rome 2006
'I Can Feel Your Smile', Lehmann Maupin –
New York 2005
'When I Think About Sex…', White Cube –
London 2005

RECENT GROUP EXHIBITIONS

Royal Academy Summer Exhibition, Royal
Academy – London 2007
'Lights, Camera, Action', Whitney Museum
of American Art – New York 2007
'Youth of Today', Schirn Kunsthalle –
Frankfurt 2006
'Body', Vancouver Art Gallery – Canada 2005

Emin was made a Royal Academician in 2007.

ACKNOWLEDGEMENTS

Alexandra Hill, Arthur Pendlebury-Green at
Bayle Pond Residents' Association, Amanda
Oates and Chris McCreedy at Shepway
District Council, Julie Houghton and Sarah
Boundy at Southeastern Trains, Jerry Hughes
at AB Fine Art Foundry and Dave Williams
at MTech.

The Proper Steps for Dealing with an Unwanted
Pregnancy (excerpt from *Strangeland*)

Always use a condom – carry them with you 24
hours a day. If things go a bit rumpy-pumpy and
the condom breaks, do not lie back and think of
England. A modern-day old wives' tale recom-
mends using Coca-Cola. If you have been shag-
ging *alfresco*, roll on to your back and have your
young man assist with a bottle of Evian. Then
jump around on the spot for five minutes. This
may be fun – though it will not work.
Go straight to the chemist and buy the morning-
after pill. It actually works up to 72 hours later. So
do not freak out if you are nowhere near a chemist,
or if it is Saturday night. Also, call Talking Pages
– they can give you the address of the nearest 24-
hour chemist.
When you take the pill, try to be calm and not too
hungover. And eat something, as there may be
side-effects. Also, you may be feeling physically
fucked-over and not just fucked.
If, for some reason, you did not take the morning-
after pill, and your period is one minute late, go to
the chemist and buy *two* pregnancy tests – Boots
does a very good deal. Do a test straight away,
preferably first thing in the morning, and the
second in the evening. That way you can be more
sure of a true result, in the event that you have a
hormone imbalance.
If the test shows positive, call a friend that you re-
ally trust – maybe your boyfriend – and discuss the
pros and cons.
If you decide that a baby is impossible, call the
Family Planning Clinic, the Brook Street Advisory
Centre, or anywhere that will advise on unwanted
pregnancy. If you have an understanding GP, call
them too.
Have a blood test and a pregnancy test to be 100
per cent sure that you are pregnant.
At this point, you could ask for a coil to be in-
serted. This is painful, but it will ensure that the
pregnancy will go no further. (I'm not sure if it's
legal, but I did it some years ago. True, I couldn't
stand the idea of sex ever again, but it worked.)
Insist on having an abortion as soon as possible.
If you have the money, you can be treated within
24 hours. If you go through the National Health
Service, you may have to wait up to six weeks.
Do not keep your pregnancy a secret, as closely
guarded as the Crown Jewels. You may need moral
support before an abortion, as you will feel shit,

weak, maybe sick and afraid. Talk it through.
Go to the clinic with a friend, not just for the op-
eration but also for a preliminary visit.
Check that the place is clean and the staff are
understanding. Once a date is fixed for the termi-
nation, do not go out on a guilt-ridden drunken
binge. Stay calm.
After the procedure, you may feel euphoric with
relief. Be careful: depression may follow. If you feel
terribly ill, go back to the clinic immediately. Two
per cent of terminations fail. If the evacuation was
not complete, the consequences may be fatal.
After a termination, some women feel fine, almost
as though nothing has happened. Others feel ex-
tremely weak. Make sure that you have nothing im-
portant to do for the following 48 hours, that you
have food at home and somewhere comfortable to
curl up. You will need some care and attention.
If you feel you made the wrong decision, or if you
suffer from guilt, ask for counselling. Regret is
natural, but will pass with time. There is, too, the
possibility that you may take out some kind of
guilt-aggression on your partner (if you have one).
There is always the possibility that the termination
will result in the end of your relationship, simply
because you feel you have experienced something
so utterly alone. This is why it is good to talk
through beforehand the decision to terminate.
You may feel terribly broody and want to steal
babies. And you stand a high chance of falling
pregnant again immediately. So maybe for a short
period, such as six months, go on the pill. Just
make sure that you are given one that suits you.
Drink lots of rose-hip tea, eat beetroot and take
iron pills. Red meat, too, if you aren't a veggie.
But the best thing is Floradix, available in tablet or
liquid form from all health shops.
Think positive. Concentrate on all the things you
could not do if you had a baby.
Exercise.
Try not to get too out-of-your-head as some weird,
deep-seated emotions might fly to the surface
when you least expect them.
Beware of phantom pregnancies.
And, most important, if you decide to have a baby,
don't listen to anyone. Just listen to your heart.

Opposite:
Baby Things, Sock, bronze, 2008

Overleaf:
Baby Things, Shoe, bronze, 2008

AYSE ERKMEN

ENTANGLED

Folkestone is home to several Martello towers positioned along the coastline at key vantage points. They were built by the British Army around 1804 as defensive points against Napoleon's army, which never arrived.

Martello tower No. 4, in the far west of Folkestone, is among the 25 towers still remaining in the town. It is completely covered with dense ivy, as if it had created its own camouflage. Being a little too much and unruly, I wanted to give it a nice sculptural "haircut" as my first project proposal for the Triennial. This proposal was not realisable as the huge amount of ivy was thought to be necessary for the tower's maintenance and would need to stay as it was.

I then turned my gaze to its counterpart, tower No. 3 on the east cliff. Having been a visitor centre in recent years, it now remains unused on top of a grassy mound. I felt that by this time No. 3 was already anxious and jealous of No. 4, because of not having one bit of ivy itself, although it stands in the middle of a very prominent location, with great sea views. I wanted to give this tower all it could ask for: a designer ivy with a name, "Algue", designed by celebrated designers Erwan & Ronan Bouroullec in three colours, green, red, white; a camouflage; an Indian summer; four seasons at once; a contemporary outfit. All prepared for the first international festivity in its home town.

Opposite:
Entangled, 'Algue' (plastic), nylon netting, stainless steel, 2008

BORN

Istanbul, 1949. Lives and works in Berlin and Istanbul.

Ayse Erkmen's spectacular public projects and subtle architectural interventions engage with the architectural, historical and cultural context of the site she is working with.

RECENT SOLO EXHIBITIONS

'Habenichts', Galerie Barbara Weiss – Berlin 2007
'Scenic Overlooks', Galerist – Istanbul 2005
'Under the Roof', IKON – Birmingham 2005
'Busy Colors', Sculpture Centre – New York 2005
Hamburger Bahnhof, Berlin, autumn 2008.

RECENT GROUP EXHIBITIONS

'Beyond the Wall', Berlin Freeport of the Arts – Germany 2007
Echigo Tsumari Art Triennial – Japan 2006
'Eindhoven Istanbul', Van Abbemuseum – Eindhoven 2005
'Who is singing over there?', National Gallery – Sarajevo 2004

ACKNOWLEDGEMENTS

Ian Lander/MDM Props, Erwan and Ronan Bouroullec, English Heritage, Vitra

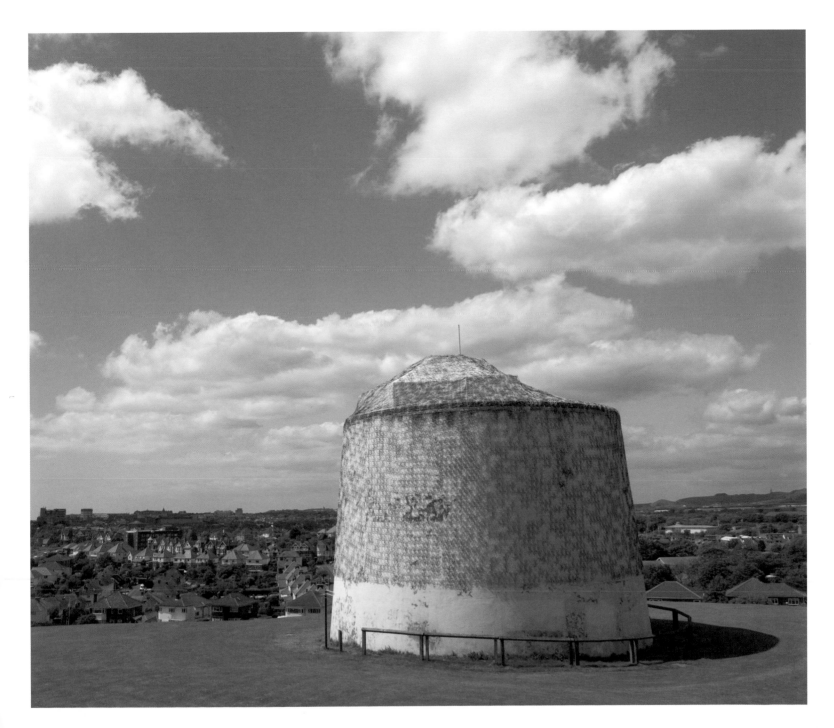

BORN

Sarajevo, Bosnia and Herzegovina, 1976.
Lives in Sarajevo and Berlin.

Šejla Kameric uses mainly photography
and video as media to juxtapose an explicit
social context with intimate perspectives.
She creates tense artefacts from society
through an almost obsessive documentation
of details and objects surrounding her. Public
interventions, diverse types of actions and
site-specific installations are among the most
important aspects of her approach to art.

RECENT SOLO EXHIBITIONS

'Is it rain or is it a hurricane', Emil Filla
Gallery, Ústí nad Labem – Czech Republic
2008
'What Do I Know', DAAD Gallery – Berlin
2008
'Mit tudok, Trafo', House of Contemporary
Arts – Budapest, Hungary 2007
'What Do I Know', O.K. Centre for
Contemporary Art – Linz, Austria 2007
'Brand New', Contemporary Art Institute
EXIT – Kosove 2006
'Šejla Kameric (Another Expo – Beyond the
Nation-States)', Gallery SOAP, Kitakyushu
– Japan 2005

RECENT GROUP EXHIBITIONS
AND FESTIVALS

(30th) Clermont-Ferrand Short Film
Festival, in competition – France 2008
(64th) Venice International Film Festival,
Corto Cortissimo, in competition, world
premiere – Venice 2007
'Hell is… other people', Stedelijk Museum
Bureau – Amsterdam 2007
'History Started Playing With My Life', The
Israeli Center for Digital Art, Holon – Israel
2007
'Zones of Contact', 15th Biennale of Sydney
– Australia 2006

Kameric was awarded the DAAD Fellowship
in 2007

ACKNOWLEDGEMENTS

Peter Kemp, Glyn Richmond, Karen and
Paul Rennie, Michael Stainer, Jonathan
Green, Lynne Mayer, Karen McLennan,
Mr Islam, Paul Dixon, Andy Ross, Nick and
Dee Grant, Rosie Holroyd, Ian Luck, Greg
McDowell, Laura Pinkham.

ŠEJLA KAMERIC

I REMEMBER I FORGOT

It's my first time here. I've come straight from the railway station to the spot where we've agreed to meet. I stand alone in an empty parking lot. My first glance of the place. The Water Lift is now opposite the sea, where once the Pier was, opposite the Amusement Park. All this will soon disappear without me knowing about it. The tarmacked plot with a white grid on it, the empty parking lot, speaks of open possibilities and decisions of how to reorder the past and the future. Only afterwards will those ordinary moments claim remembrance. I may see a person sending a bottle with a blank message in it. And a person who sees the bottle, but is unable to reach it. Then a person who finds the bottle, breaks it, sees the message, only to realise that the message has faded with time.

Opposite:
I remember I forgot, Rotunda, framed photo poster, 50 × 70cm

Overleaf:
I remember I forgot, Road, poster, 3.6 × 4.2m, 2008
I remember I forgot, Fish Market, framed photo poster, 50 × 70cm; installation at British Lion Pub

ROTUNDA

No plot, no climax, no denouement, no beginning, no middle and no end.
An unnecessary stain on silence and nothingness. Happy days.

Suzanne Deschevaux-Dumesnil & Samuel Beckett, 25th March 1961, Folkestone

ROBERT KUSMIROWKSI

FORESHORE

BORN

Poland, 1974. Lives and works in Lodz, Poland.

Robert Kusmirowski is celebrated for his sculptural simulacra. The work takes the form of detailed reconstructions and perfect copies of old official documents, newspapers, photos and ID documents, but also monumental pieces such as a graveyard or train carriage. He held his first exhibition in Poland in 2001.

RECENT SOLO EXHIBITIONS

Van Abbemuseum – Eindhoven 2005
Foksal Gallery Foundation – Warsaw 2005
'The Ornaments of Anatomy', Kunstverein – Hamburg 2005
'D.O.M', Johnen Galerie – Berlin 2004
'Double V', CCA Castle Ujazdowski – Warsaw 2003

RECENT GROUP EXHIBITIONS

'Of Mice and Men', 4th Berlin Biennial – Germany 2006
'4Ks2/63', Auschwitz Prozess Ausstellung, Frankfurt – Germany 2004
'Distance?', CCA La Plateau – Paris 2004
Artistic Initiative Domestic – Lublin, Poland 2003

The inspiration for my work is a dialogue between what is alive and what is dead, between something yet to be created and something already gone. It is people and places that are forgotten. This trajectory between past and present, the traces of what has been left behind, is an important impulse. To explore these physical as well as mental places and to transform something that is ethereal into something material becomes a kind of magic.

For me, my own physical exploration and involvement in the work is as important as its intellectual conception. My need to build the work entirely by myself is in fact a need to hear my inner voices. When I feel physically exhausted, mind running on adrenalin, it is easier to experience the subject. In this state, I frequently improvise as new shapes evolve more exquisitely than if pre-planned.

I am materialising apparition, allowing dreams to take form. The vision of people evicted from a metropolis for unknown reasons has become an important dream-scenario for me, and with it the desire to observe and experience a "ghost city". Inhabitants would have to leave everything in a second. Their doors remain open, so it becomes possible to enter all areas. The Chernobyl disaster and Ukrainian city Prypait, called "the Ghost City", are perhaps the source of this dream. To date, this place is frozen in time. Personal things are left behind, dishes on the table, toys on the floor. It becomes a kind of "archi-tectural exhumation", recalling the presence of the people who lived there.

The old harbour in Folkestone shows all the traces of its former life, traditions and customs, as well as signs of its extinction. My work is an imagined reactivation of the old harbour together with its fittings and former beauty. A place that has never existed, but is now given form. The partial visibility at high tide and the inherent gradual destruction of the old fish market by water and time are central parts of its concept. During three weeks in May I constructed the fish market from harbour debris collected during a year in Folkestone. Reality and fantasy have merged. It's a kind of "anatomical examination", a visual, mental and olfactory construct. It is important to remember what man has created, invented and left behind. That is the essence of my actions. I am obsessively looking for these evocative historical moments to then translate them in my work for the contemporary recipient.

Opposite and overleaf:
Foreshore, timber, driftwood, harbour detritus, dimensions variable, 2008

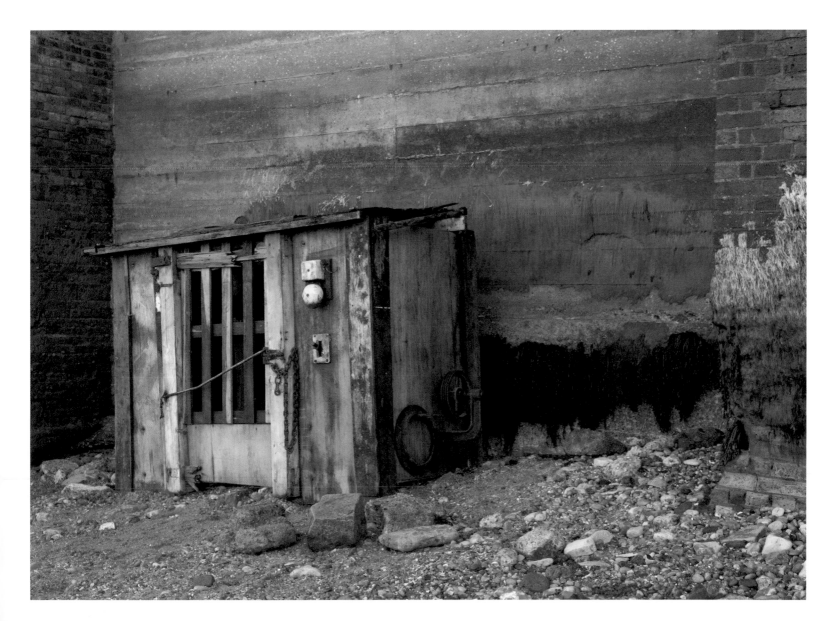

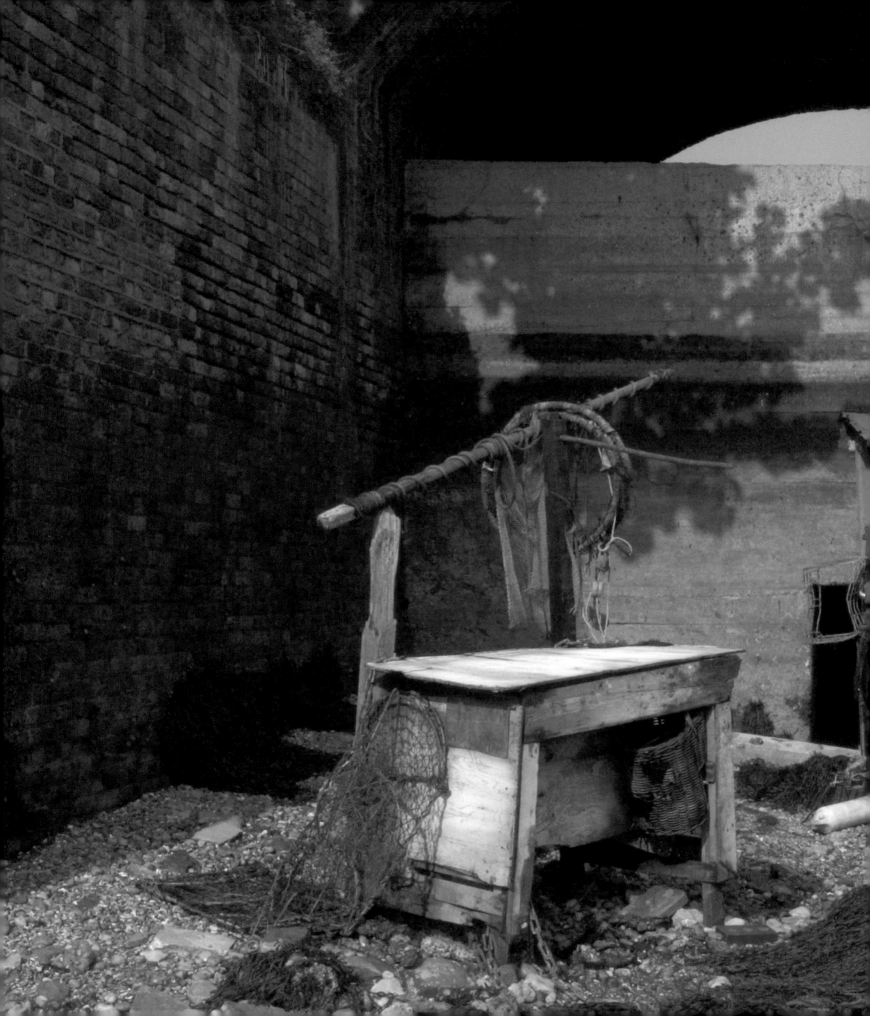

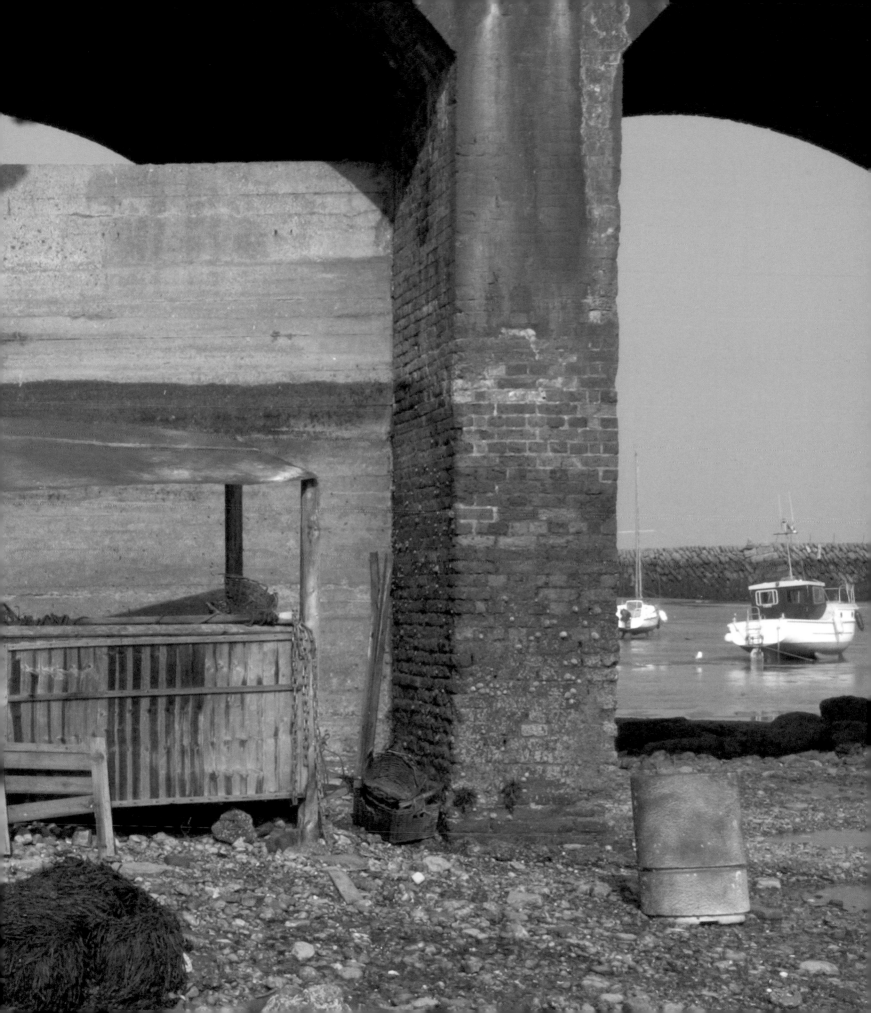

LANGLANDS & BELL

FOLKESTONE: BOULOGNE

A Blind Date

BORN

Ben Langlands, UK, 1955; Nikki Bell,
UK, 1959. Both live and work in Kent and
London.

RECENT SOLO SHOWS INCLUDE

'A Muse Um' Alan Cristea Gallery – London
2008
'Whitechapel Laboratory', Whitechapel Art
Gallery, London - 2007
'Superactive i2i', Somerset House – London
2007
'Zardad's Dog', Tate Britain – London 2005
'Plunged in a Stream', Site Archéologique
du Coudenberg – Ancien Palais de Bruxelles
2005
'The House of Osama bin Laden', Imperial
War Museum – London 2003

RECENT GROUP
EXHIBITIONS INCLUDE

'Eye on Europe - Prints, Books, & Multiples /
1960 to Now', Museum of Modern Art, New
York 2006/2007
'Panopticon', The Architecture and Theatre
of the Prison, Zacheta National Gallery of
Art – Warsaw 2005
'Playground', 6th International Exhibition of
Architecture, Art Play – Moscow 2005
'3rd Seoul International Media Art Biennale'
Seoul Museum of Art, Seoul, 2004/5

In 2002 Langlands & Bell were commissioned
by the Imperial War Museum, London to
research "The Aftermath of September 11 and
the War in Afghanistan". In 2004 they won the
BAFTA Award for Interactive Arts Installation
for "The House of Osama Bin Laden", the
trilogy of works which resulted from their visit.
In the same year they were nominated for the
Turner Prize.

Last year we went into a pub in Kent. It was
almost empty, with an enormous parrot cage in
the low-ceilinged bar. A giant plumed cockatoo
sulked silently on its perch in the half light. As the
pub began to fill with people, the parrot became
restless. Suddenly a stream of obscene language
and wicked cackling giggles erupted from the cage.
Before people could even look up to discover the
source of the outburst, the parrot had resumed its
hunched, sulky posture.

We asked the landlord about the parrot. He told us it
was a guest in his pub, and that it belonged to a sailor
on a marine salvage tug who had to go to hospital for
an operation. Because the parrot swore so much, the
man's wife had refused to allow it to stay in the house
in his absence. His daughter, who worked behind the
bar at the pub, asked if the pub could provide the
homeless parrot with temporary accommodation.

The landlord asked us what were doing in the area.
We said we were on our way to Folkestone to shoot
some video for an artist's film about Folkestone
and Boulogne. He told us the parrot's boat was
moored in Folkestone and we should meet the cap-
tain. We called Captain Reynolds, who invited us
to join him aboard the *Anglian Monarch* for three
days traversing the Channel between Folkestone
and Boulogne. That's where the film began, at
sea between two towns 22 miles apart. Boulogne:
Folkestone.

Opposite and overleaf:
Production stills from *Folkestone: Boulogne*, video
projection, 15 minutes, 2008

KAFFE MATTHEWS

THE MARVELO PROJECT

BORN

Good Easter, Essex, 1961. Lives and works in London.

Kaffe Matthews has been making and performing new electro-acoustic music since 1990. She is internationally acknowledged as a leading figure and pioneer in the field of electronic improvisation and live composition, and established the label Annette Works, www.annetteworks.com in 1996. Currently, she is performing rarely, as she directs the collaborative research project Music for Bodies (www.musicforbodies. net), making music to feel not just listen to through specialist sonic interfaces (NESTA Dreamtime Fellowship, 2005).

RECENT WORK

'Sonic Bench', Mexico, concrete Sonic Bench, Transitio-Int.MX-02, Laboratorio Arte Alameda – Mexico City 2007
'Viewing 1', for roaming wireless headphones (a Roulette commission), the World Financial Plaza – New York 2007
'Body Abiding' with BBC Scottish Symphony Orchestra and Jonathan Harvey, City Halls, Glasgow – Scotland 2007
'Sonic Bed', Shanghai playing 12 channel work 'Horn', British Council, Xuhui Art Museum – Shanghai, China 2006
Sonic Bed', London playing 12 channel work 'Bend', 'Her Noise', South London Gallery – London 2005
'This is for you', text and chaise longue, playing John Cage, Arnolfini Gallery – Bristol 2005
'Three Crosses of Queensbridge Rd', bicycles+radios, 'Sounds Like Drawing', Drawing Room – London 2005
'No-one here but us chickens', for 8 instrumentalists, 'Sound of Heaven+Earth', Tate Modern – London 2005

SIGNIFICANT COLLABORATIONS

The Lappetites, MIMEO, Eliane Radigue, David Muth, Shri, Mandy McIntosh, Zeena Parkins, Brian Duffy, Sachiko M, Ikue Mori, Pan-Sonic, Alan Lamb, Christian Fennesz.

ACKNOWLEDGEMENTS

Abigail, Bradley, Charlotte, Hannah, Harrison, Holly, Leonie, Paul and William from the Folkestone Academy, Lisa Hall, Alexei Blinov and Wolfgang of Hive Networks, Peter Edwards of e-2.org, David Cranmer.

I am making music for outside spaces. Reconsidering time through building non-linear works that hover invisible in the air until they are triggered to play by a passing visitor. I am investigating this in two ways: one is for full body listening and static, the other for expansive ear listening and roaming. Both instances create audio environments away from our self-controlled solo perambulating sound spaces, the roving headphones, the self-designed portable home space transfer systems. Both instances also put new music on to the street, away from the confines of the concert hall or the gallery, away from the start-finish ritual of the performance, inadvertently turning the visitor into performer and transforming the public sound space, sometimes so subtle, into patches of musical vitality. Was last night so good, or was that really a trumpet gliding by?

Let's rework spatial considerations, exploring maps as musical scores and mapping as shifting structures moving in networked layers. Hook fragments of pieces on to them and use invisible connection possibilities to start and stop and recombine the sounds afresh, depending on where you, the listener, goes on the street.

The full body static listening techniques I'm exploring produce music that is physically experienced through comfy concrete Sonic Benches,[1] the map of the resting body so becoming the score. Expansive, roaming listening uses the street, the maps, our routes as scores, with the listener carrying the music through neighbourhoods on an audio bicycle. I have used FM transmission to do this previously,[2] but Folkestone is not local radio friendly. UK control of the airwaves and cost of licensing, combined with the power of French signals and the hills of Folkestone, have pushed us (! – good!) to find another means.

Mar – fabulous, *velo* – bicycle, *Marvelo* – cool. A beautiful fat-walled Martello tower makes a perfect sound laboratory, overlooking the Folkestone streets below. Throw a net. Catch the digits beamed down from space that mark our streets, our fields, our land and sea as numbers, and map them. Work with brilliant young ears and minds of local residents, make music that tells of their thoughts and places and attach these pieces in sonic fragments to the map of digits. Then travel.

You will be able to hear the work unfold locative. Unfurl, jump out, reveal itself in fragments and phrases and silence and noise and threads of melody as you go. Sounds collide at the corner and switch, no end, bang into another libretto as left you go instead. Hark how fresh and varied the sonic landscape becomes, how you tune into those details near and far. We have invaded and transform it.

Why pedal on two wheels?
The bike carries the hardware, leaving you to float around listening, and the downs truly make the ups more than worth it.

1. *http://www.musicforbodies.net/wiki/Sonic_bench_design*
2. *kaffematthews.net/radio_cycle*
See also: *http://kaffematthews.net/wiki/marvelo*

Opposite:
Marvelo workshop with children from Folkestone Academy, March 2008.

Overleaf:
The Marvelo Project, second-hand bicycles, each mounted with Hive Box, gps receiver, 12V battery stereo sound system, solar powered trickle charger, audio files, 2008

IVAN & HEATHER MORISON

TALES OF SPACE AND TIME

BORN

Ivan Morison, UK, 1974; Heather Morison, UK, 1973. Both live and work in Wales.

The Morisons' work varies from performance, video, photos, text and audio pieces to a garden and an arboretum – all modest documentations of naturally occurring man-made phenomena, real and unreal.

RECENT SOLO EXHIBITIONS

Bloomberg Space – London 2007
'Earthwalker', Danielle Arnaud Contemporary Art – London 2006
'Camden Arts Centre Tree Tour', Camden Arts Centre – London 2006
'Starmaker', Charles H Scott Gallery – Vancouver 2005
'Chinese Arboretum', Q Arts – Derby 2005
'Heather & Ivan Morison do not understand it', IPS – Birmingham 2004

RECENT GROUP EXHIBITIONS

'Zoorama', part of 'Thin Cities', Piccadilly Line, Platform for Art – London 2007
British Art Show 6 – Manchester, Nottingham and Bristol 2006
'Human Nature', Pump House – Battersea, London 2005
'The Art of the Garden', Tate Britain – London 2005

The Morisons completed their first science-fiction novel *The Divine Vessel* in 2003 and created a bedding scheme for the City of Westminster in spring 2004. They represented Wales at the 52nd Venice Biennale 2007.

ACKNOWLEDGEMENTS

Giles, Dylan and Ellen.
Wig Worland (photography)

Ivan Morison: What made you build your first truck?

Roger Beck: The first one I call my escape vehicle! I grew up in LA, a metropolitan, screwy city. And so it just got to the point where I just had to get out. So I left a whole bunch of stuff I didn't want to get rid of at my parents' house and got into my first house car and headed north. I couldn't head south 'cause I had long hair and didn't want to cross the Mexican border; I couldn't go any further west; the east coast was nothing more than big cities to me and so I decided to go to Canada! It was my escape route. I got to Oregon and then I did a stupid thing. Me and a friend ripped a tape deck out of a logging truck and I was arrested the same day and I was put on five years' probation. And in those five years I built my second house truck, which had a lot of problems. I drove it to California again to see my parents and my father and I built my third truck. He really helped me to build a house on the back of a truck. I travelled most of my travels in that one. I had the idiosyncrasy of trying to distinguish myself as a New Age American Gypsy and not a hippy living in a school bus with a bunch of mattresses in the back. That's not a house truck, that's because you're homeless and you can't afford to live in an apartment, which you'd prefer to do. I had no desire to live in a house. I had my house; it was just on wheels.

Ivan: Was there anyone doing this before you in America?

Roger: For me, when you think about house trucks, you've got to go back to the depression. People were living in rigs because they couldn't afford to live anywhere else.

Ivan: Were you coming from a political standpoint at the time?

Roger: Well, a lot of the politics came out of the Vietnam War – trying to escape all of that, to be free. It was an era when gas was fairly cheap and the idea of being free was desirable.

Excerpt from a conversation with Roger D. Beck at his workshop in Eugene, Oregon, January 2007.

Roger Beck was one of the first pioneers of the house truck movement back in the 1970s on the west coast of America: a loose grouping of people who felt discontent with the ways in which they were being made to live, who struck out with a nomadic model for living of their own. We made a journey back in early 2007 to track down many of those early house truckers and to talk to them about what they were escaping from and to see if they had succeeded. We also had a notion that a new younger generation of Americans were now equally discontent with parallel political and social problems, and we wanted to see whether the idea of escape was still possible, or whether this newer generation were too embedded into their culture to truly escape from it. Our findings relating to that are for another essay, but, in summary, the trip left us fascinated by the possibilities of the escape vehicle.

So to Folkestone, with its links to one of the greatest science-fiction writers of all time, H.G. Wells, the inventor of one of the finest escape vehicles of all time, the Time Machine. What a remarkable vehicle that can take you to any point in the past or the future, where you can witness what became of mankind and the earth, and then be safely whisked away.

We wanted to build our own escape vehicle; one, a bit like the Time Machine, that equipped its occupant with the knowledge of every imaginable future and mankind's solutions to these problems. We chose a Green Goddess, an old military fire engine, to build our house truck on to (a little more rugged and more in the modern survivalist vein than the New Age American Gypsies perhaps) and filled it with a library of the finest apocalyptic, post-apocalyptic and catastrophe science-fiction literature.

For the duration of the Triennial the truck will tour around Folkestone; an incongruous addition to the usual street scene; open to visitors to borrow books and to read up on possible futures; a reminder to be prepared.

We built the house truck in the true west coast house truck spirit; felling and milling our own timber for the build. We have a man who comes with his mobile sawmill to mill timber for us. When he came for this project the Goddess was parked up in the wood. He told us that he used to be in the RAF and that these Green Goddesses used to be all stored, three high, in huge hangers on an airbase somewhere. There were so many that it was the job of a whole team of mechanics just continuously to service them. The thing is that these fire engines weren't all stored there for when the fire service went on strike, but for when the apocalypse did happen. These machines were designed and kept in all readiness for that event. Our Goddess was built and put into service in 1954. The army decommissioned all their Goddesses last year. I don't know if that's because they've replaced them, or whether they have decided the end isn't coming just yet.

Opposite and overleaf:
Tales of Space and Time, converted Bedford Green Goddess, Douglas Fir, books, multi media, 2008

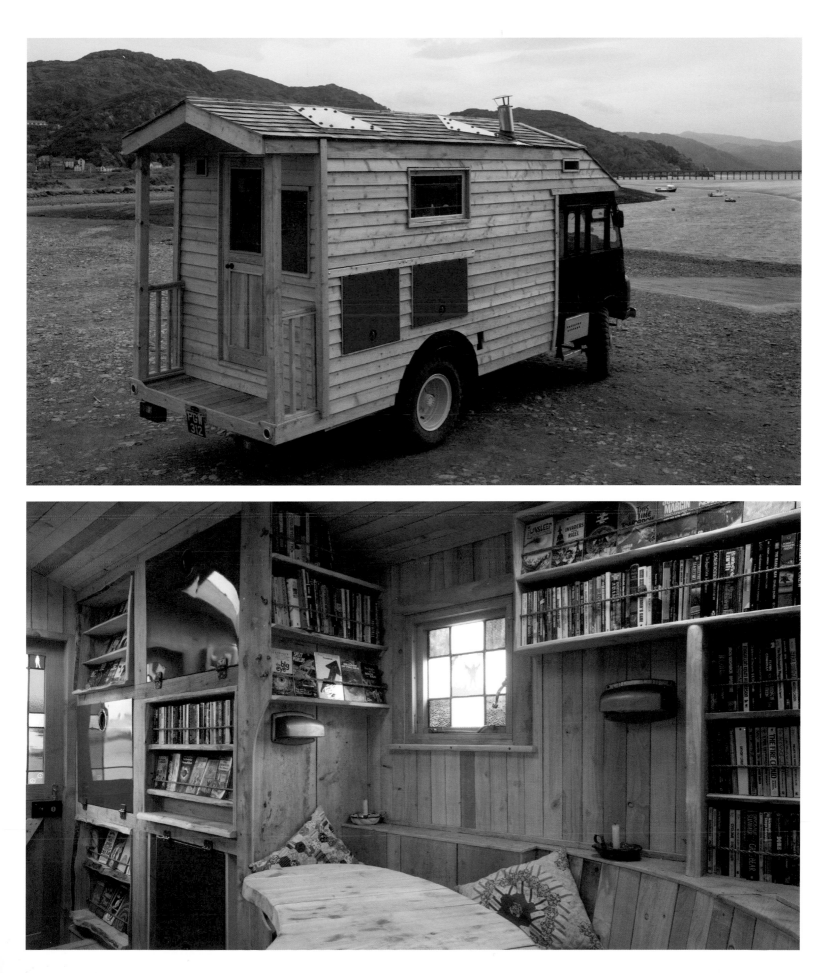

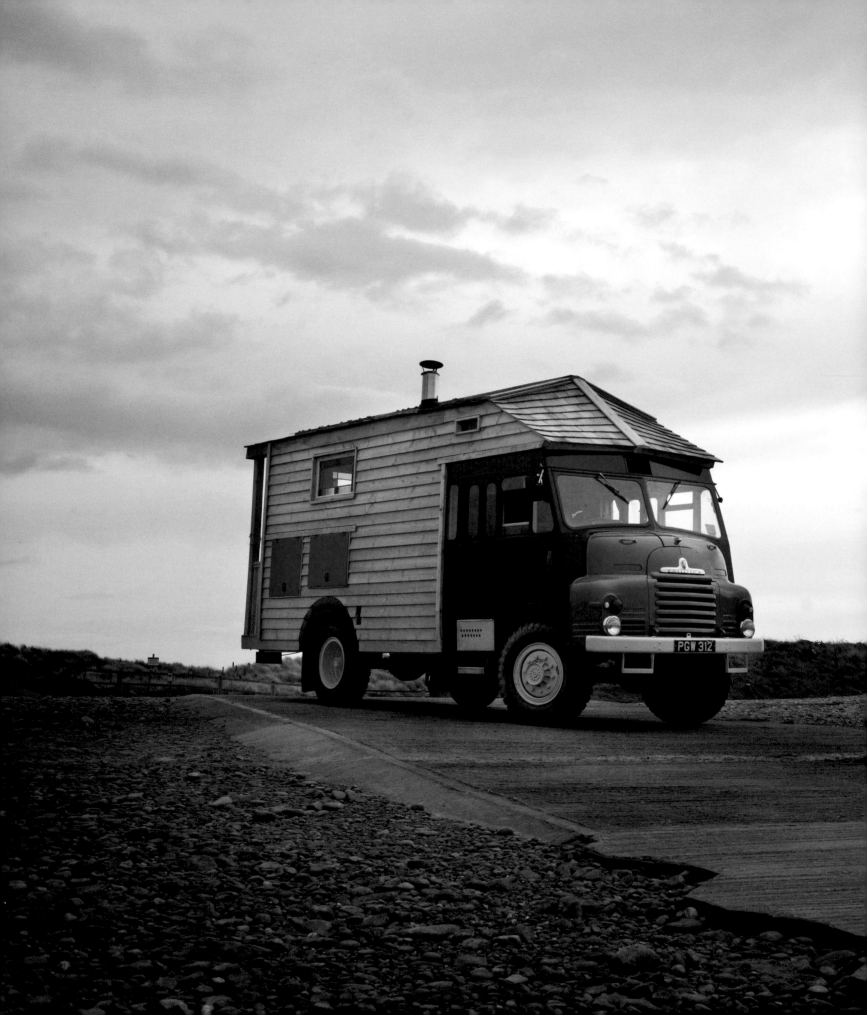

NILS NORMAN WITH GAVIN WADE MIT SIMON & TOM BLOOR

KIOSK5: KITEKIOSK

NILS NORMAN
BORN

East Sussex, 1966. Lives and works in London.

Nils Norman has developed his own mix of art and activism, examining histories of utopian thinking and ideas on alternative economic systems that can work within urban living conditions.

RECENT SOLO EXHIBITIONS

'A Mysterious Thing', Nils Norman and Stephan Dillemuth, Vilma Gold – London 2007
'Degenerate Cologne', Galerie Christian Nagel – Köln 2006
'The Homerton Playscape Multiple Struggle Niche', City Projects – London 2005
'Hey Rudy!: A Phantom on the Streets of Schizz', Galerie Christian Nagel – Berlin 2003

RECENT GROUP EXHIBITIONS

'Global Cities', Tate Modern – London 2007
'It Starts From Here', De La Warr Pavilion – Bexhill on Sea 2007
'Make Your Own Life', ICA Philadelphia – Pennsylvania, USA 2006
British Art Show 6 – Newcastle (touring) 2005/2006
'Down the Garden Path: Artists' Gardens since 1960', Queens Museum, Queens – New York 2005
50th Venice Biennale – Italy 2005

GAVIN WADE
BORN

Birmingham, 1971. Lives and works in Birmingham.

SIMON & TOM BLOOR
BORN

Both in Birmingham, 1973. Live and work in Birmingham.

Gavin Wade mit Simon & Tom Bloor are an artist group formed in 2005 and based in Birmingham. With a shared interest in modernist design and architecture and the proliferation of ideas and images through print, they are sending Lubetkin's kiosk on new adventures around the globe, giving the kiosks a new lease of life as their multitude of uses grows.

RECENT EXHIBITIONS

Kiosk7: OudWestKiosk, SMART Project Space, Amsterdam – Netherlands 2007
Kiosk6: Intellect&ComprehensionKiosk, Isola di san Servolo – Venice 2007
Kiosk3: MerzKiosk, Magazin4, Bregenz – Austria 2006
'What are the senses?', Dudley Zoological Gardens – Dudley 2005

ACKNOWLEDGEMENTS

Ian Lander/MDM Props

Nils Norman has invited Gavin Wade mit Simon & Tom Bloor to collaborate with him on creating a temporary modernist kiosk structure for Folkestone's The Leas. *Kiosk5: KiteKiosk* brings together three recurring themes of the British seaside – modernism, culture and regeneration.

In the 1930s modernist design succeeded the more traditional Edwardian and Victorian styles through the attempts of local councils to regenerate seaside towns. Functioning as "engines of the new industry" of leisure and culture, this new fantasy architecture reflected the ocean liner and the sophistication of the South of France.

The finest example of these ambitious dreams is Bexhill's De La Warr Pavilion, just along the coast from Folkestone. Other examples include Pevensey Bay's "Oyster" bungalows; the Wells Coates designed Embassy Court in Brighton; Marina Court and the marina, St. Leonards; Saltdean's lido; and "the concrete king" Sydney Little's functionalist walkways and shelters for Hastings and St. Leonards' promenade.

In recent years the utopian aspirations of the 1930s "seaside modernism" have returned. The De La Warr Pavilion has been resurrected as "destination architecture" and a catalyst for the town's regeneration, stepping back into its original function to become, in Lord De La Warr's words, "a crucible for creating a new model of culture provision in an English seaside town". Utilising culture as a strategy for urban renewal has once again become an essential part of central and local government's regeneration plans. Evidence of this can be seen in the success of cities such as Newcastle and Gateshead, the publication of the Department of Culture, Media and Sport's paper *Culture at the Heart of Regeneration* in 2004 and within the Folkestone Triennial.

Kiosk5: KiteKiosk is one of many kiosks to be adapted by Gavin Wade mit Simon & Tom Bloor from *Kiosks1&2*, two buildings among a set of enclosures created for Dudley Zoo in 1937 by the Russian architect Berthold Lubetkin. Architect John Allen suggested that more of the British public first encountered modern architecture through Lubetkin's zoo work than via any other means. After an initial project at Dudley Zoo in 2005, the artist group is metaphorically running with *Kiosks1&2*, introducing a series of artworks to places far and wide in order to create a vision of the world tamed, not with a fist, but with a kiosk!

Kiosk5: KiteKiosk, temporarily located on Folkestone's The Leas, will distribute simple black and red diamond-shaped kites. Half of these will have the culture and regeneration buzz-phrase "Hipsterization Strategies" (bringing artists and creative types, or "hipsters", to a town or area to gentrify it) printed on them, the other half a phrase taken from the writings of the Marxist geographer David Harvey – "Uneven Development" – alluding enigmatically to the possible outcome of these impossible class-divisive urban restructuring methods. Visitors will have the opportunity to fly these phrases over Folkestone as they participate in the Triennial and see the ideas float above the town. Also available from the kiosk is a specially made booklet, completing the artwork with a dialogue between Lubetkin and the early pioneer of manned flight, showman and kite innovator Samuel Franklin Cody.

Opposite:
Design for Kites

Overleaf:
Kiosk5: KiteKiosk, steel, plywood, timber, fibreglass sandsurface, kites and booklets, 2.75 × 8.5 × 5.25m, 2008

UNEVEN DEVELOPMENT

HIPSTERIZATION STRATEGIES

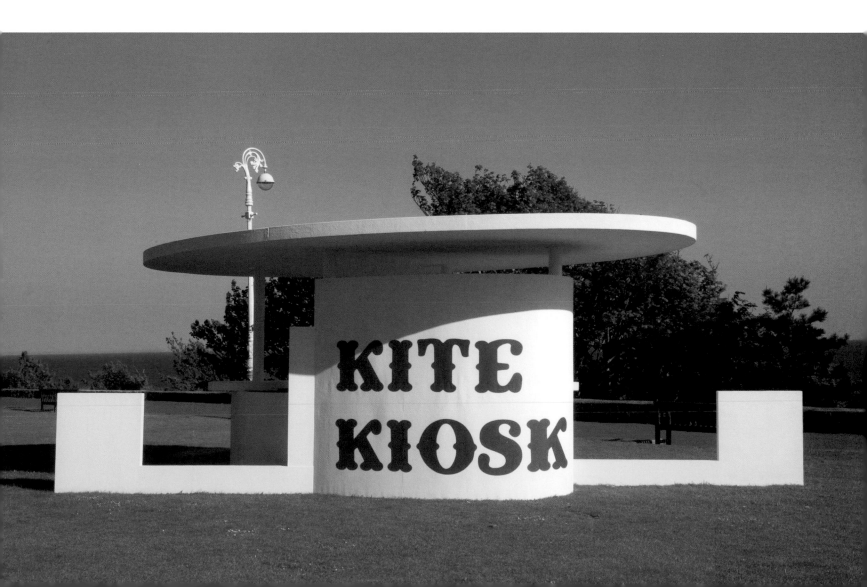

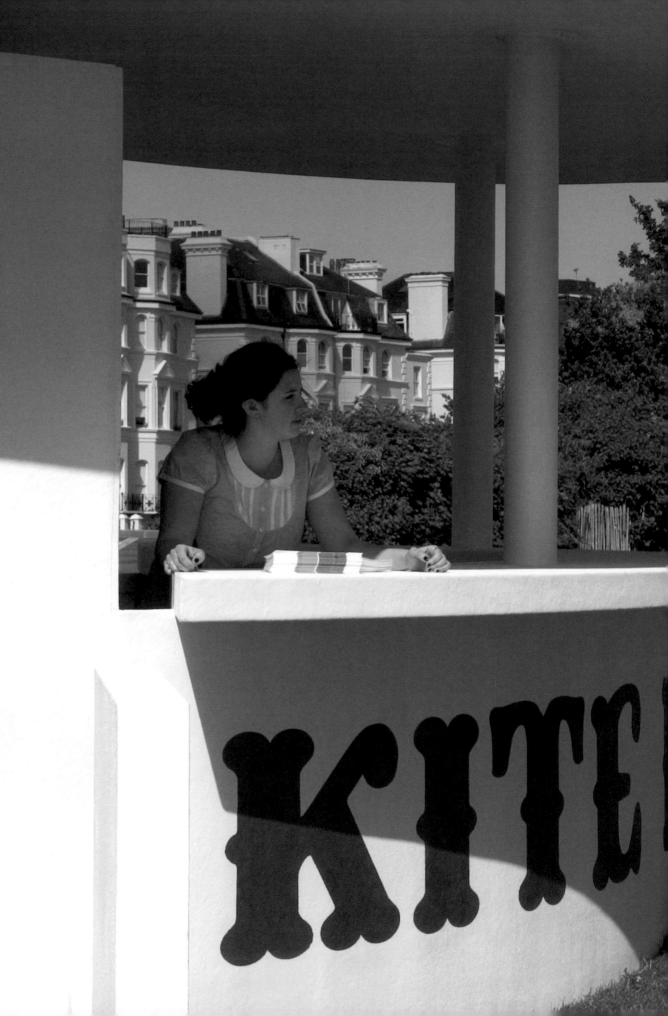

SUSAN PHILIPSZ

PATHETIC FALLACY

"This world may never change
The way it's been
And all the ways of war
Won't change it back again

I've been searching
For the dolphins in the sea
And sometimes I wonder
Do you ever think of me"

BORN

Glasgow, 1966. Lives and works in Berlin.

Susan Philipsz works primarily with sound, film and space. Her starting point is the interface and tension between subjective and collective memories of popular music, political songs and film experiences.

RECENT SOLO EXHIBITIONS

'Here Comes Everybody', Tanya Bonakdar Gallery – New York 2008
'Star Nebulue' (with Monika Sosnowska), Alte Fabrik, Rapperswil – Switzerland 2008

RECENT GROUP EXHIBITIONS

Sydney Biennial – Australia 2008
Carnegie International – Pittsburgh 2008
'Gods and Goods', Villa Manin – Italy 2008
'Unmonumental', New Museum for Contemporary Art – New York 2007
Münster Sculpture Project – Germany 2007
Busan Biennale – South Korea 2006
Berlin Biennale – Germany 2005
Becks Futures Exhibition, ICA – London 2004

Philipsz was awarded the PS1 International studio programme in New York, 2000, and the International Artist Programme at Art Pace, San Antonio, 2003.

ACKNOWLEDGEMENTS

Eoghan McTigue, Alex Sainsbury, Tris Vonna Michell, Rosemary Heather.

A recording of me singing a song called *Dolphins* a cappella by the late Tim Buckley can be heard emanating from hidden speakers in the roof of the shelter on the hill.

The sea is a place that you can get lost in, project your thoughts in. Escape. The small viewing hut on the hill was built to provide shelter while doing just that, but for some reason it was never used in this way. Like most shelters, it's become a home to the people who most need them: the homeless. Or a place for bored teenagers to hang out. The debris around shows this, giving the place a forgotten feel; forlorn and neglected. Life goes on, despite the beauty.

When I first heard *Dolphins* it reminded me of those carefree times when I was a teenager – laughing, making out, drinking beer, falling in love. But then the song brings you to the sobering reality of war that deprives so many of there youth, like all those thousands of young men who left from the shores of Folkestone during the Second World War.

Nowadays, Folkestone has become a shelter to many seeking asylum. The vast open sea must be a constant reminder of how far from home they are.

Like Tim Buckley, recurring themes in much of my work are longing, loss, escape and transcendence. *Pathetic Fallacy* attempts to project meaning on to its surroundings. The sea, the shelter and its surrounds, combined with the song, tell their own story.

Opposite:
Musical scoresheet: *Dolphins*, Fred Neil

Overleaf:
Site for *Pathetic Fallacy*, four speaker surround-sound installation, continuous loop, 2008

Dolphins

Words & Music by Fred Neil

A A7 Bm E B♭7

Capo first fret

Intro

‖: A | A | A7 | A7 :‖

Verse 1

```
A              A7
Sometimes I think about
Bm       E
Saturday's child
A              A7
And all about the times
Bm                  E
When we were running wild.
```

Chorus 1

```
       Bm              E           A  A7
I've been a-searchin' for the dolphins in the sea. ___
Bm              E          A   A7
Ah, but sometimes I wonder, do you ever think of me?
```

Verse 2

```
A              A7
This old world will never change
Bm        E
The way it's been
A            A7
And all our ways of war
Bm               E
Can't change it back again.
```

Chorus 2

```
           Bm            E          A  A7
I've been a - searchin' for the dolphins in the sea. ___
Bm              E          A   A7
Ah, but sometimes I wonder, do you ever think of me?
```

Verse 3

```
A             A7
Lord, I'm not the one to tell
Bm        E
This old world how to get along
A                A7
I only know that peace will come
Bm               E
When all our hate is gone.
```

Chorus 3

```
           Bm      E           A  A7
I've been a-searchin' for the dolphins in the sea. ___
Bm              E          A   A7
Ah, but sometimes I wonder, do you ever think of me?
```

Outro

```
A              A7
This old world will never change,
A              A7
This old world will never change,
A
This old world
A7          B♭7  A
Will never change. ___
```

PUBLIC WORKS

FOLKESTONOMY

Tagging Folkestone's Cultural Spaces

Folkestone is changing. Ambitious plans by various local organisations and instigators aim to deliver a cultural regeneration different from other places where regeneration efforts often meant the extinction of the cultural bedrock of a place that had essentially contributed to its identity.

The Folkestone Triennial is a flagship project in the local regeneration ambition. As a cultural "regenerative" event, it will contribute to various factors important to cultural and economic progress: issues of identity and image, cultural production and exchange, attracting locals and visitors, putting Folkestone on a national and international cultural map, creating employment and training, etc.

It's less obvious to comprehend how the Triennial unfolds as a social and spatial reality. How and where does it exist beyond its season of commissions? What and where are the spaces and cultural aspects that are being produced, occupied and transformed by the Triennial? Can knowledge and networks generated through the Triennial influence future cultural thinking and planning on an urban scale? How can the Triennial inform local political ambition to avoid a top-down culture-led regeneration?

FOLKESTONOMY has set out to look at the wider cultural spaces and networks that are linked to the production and delivery of the Triennial, and to visualise its links and extensions into existing cultural spaces and territories in Folkestone.

FOLKESTONOMY consists of a mobile mapping station and an evolving and changing online map. The mobile mapping station will travel alongside the route of the 23 Triennial commissions, inviting passers-by and visitors to trace and map their own links, encounters and interests with the wider field of the Triennial. This information will feed into a new and growing map of Folkestone indexing a variety of the town's different informal and formal cultural spaces, interests and networks that

have been identified and tagged by the individuals who take part in the mapping. The reasons and arguments for including data in the map can be multiple, subjective and contradictory. The aim is to sketch and show an image of an existing and extending cultural space that is important, but currently less visible than others.

The title FOLKESTONOMY is made up from two meanings:

1) "Folksonomy" is an existing term and stands for "collaborative tagging". This is the practice and method of collaboratively creating and managing tags to annotate and categorise content. The data and metadata to capture and represent a specific subject matter is not only generated by experts, but also by creators and consumers of the content. FOLKESTONOMY uses the methodology of collaborative tagging to create a new cultural map of Folkestone where the data and content is produced by passers-by and users of public spaces.

2) There is a suggestion that the word Folkestone comes from "Folca's stone", a rock marking the meeting place of local people, although it remains a mystery who Folca was and where his stone was placed. FOLKESTONOMY is a mobile meeting and mapping station to locate and register where people meet and where things are happening in Folkestone today. Many suggestions point to "outside of Debenhams" – and maybe that's where Folca's stone has been – but it's more likely that this stone has broken down in little parts which are spread all over town.

Opposite and overleaf:
FOLKESTONOMY, milk float, lap top computer, signage, dimensions variable, 2008

BORN

Kathrin Böhm, Germany 1969; Andreas Lang, Germany 1968; Torange Khonsari, Iran 1973. All live and work in London.

Public Works is a London-based artist/architects collective which has been working in different constellations of partners and collaborators since 1999. Current members are artists Kathrin Böhm and Polly Brannan and architects Andreas Lang and Torange Khonsari. Kathrin Böhm is currently a Research Fellow at the School of Art and Design at the University of Wolverhampton, and is supported by the AHRC. Public Works projects address the users of public spaces. They develop physical and non-physical forms that allow for a participatory and cross-hierarchical understanding and transformation of the spaces they work within.

CURRENT AND RECENT PROJECTS

'Village Kiosk', a self-initiated ongoing project in collaboration with myvillages.org and Grizedale Arts – 2008
'Cross country', Wysing Arts Centre – Bourne 2008
'Building Stories', in collaboration with 30 Birds Production, Quazvin – Iran 2007
'Folk Float', commissioned by Grizedale Arts, Egremont – Cumbria 2007
'Can you show me the space', Stanley Picker Gallery – Kingston 2007
'Podium', Braithwaite House – London 2006
'Make:Shift', Bagfactory – Johannesburg 2005
'Park Products' for the Serpentine Gallery, Kensington Gardens – London 2004

ACKNOWLEDGEMENTS

Dorian Moore for the development of the mapping tools and software, John Lenehan, Chris Bradley and Neil Smith from C.B.L. Electric Vehicles Ltd, Ian Lander and Marc Coey-Archer/MDM Props, Strange Cargo, Club Shepway, Leonie Koenen. School of Art and Design, University of Wolverhampton Arts and Humanities Research Council, UK (Kathrin Böhm is supported by the AHRC)

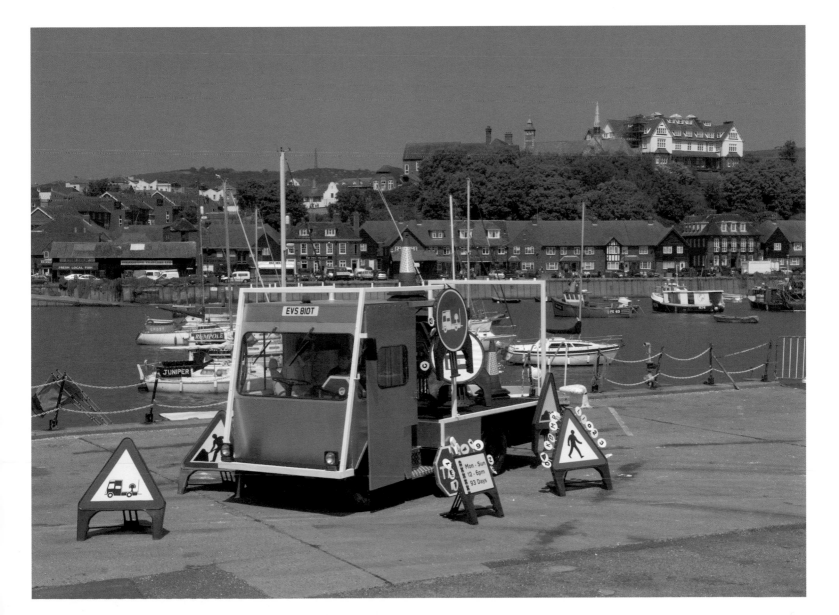

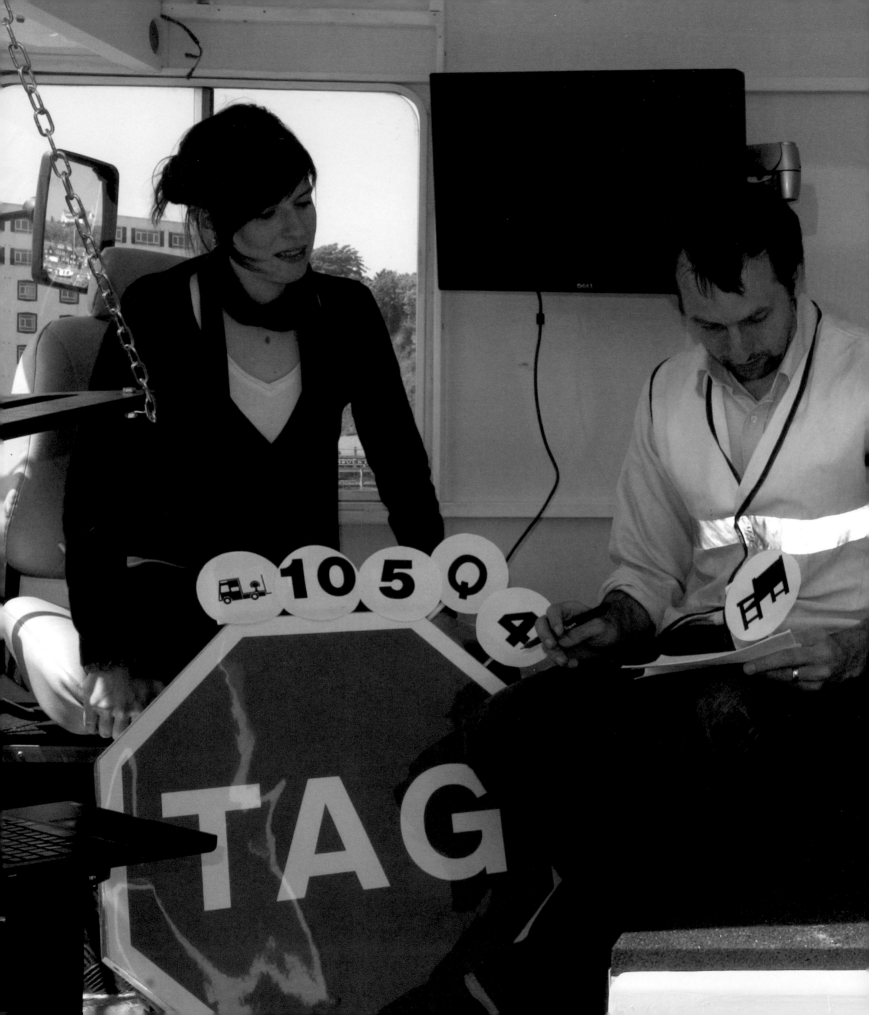

PATRICK TUTTOFUOCO

FOLKESTONE EXPRESS

BORN

Milan, 1974. Lives and works in Milan.

Patrick Tuttofuoco is known for his utopian ideals and his interest in society, cities and community. His practice is inspired by a desire for interaction and an interest in social and political dynamics, making frequent use of fluorescent colours, loud music and quirky architecture.

RECENT SOLO EXHIBITIONS

'Chindia', Haunch of Venison – London 2007
'Revolving Landscape', Fondazione Sandretto Re Rebaudengo – Turin 2006
'The Circle Guenzani', Via Melzo – Milan 2005
'My private-2', Via Pasteur – Milan 2005

RECENT GROUP EXHIBITIONS

'Mediterranée', Carré d'Art, Musée d'Art Contemporain de Nîmes – France 2007
'On Mobility', De Appel Foundation – Amsterdam 2006
'HyperDesign', Biennale of Shanghai – China 2006
'LUNA PARK. Arte Fantastica', Villa Manin Centro Arte Contemporanea, Codroipo, Udine – Italy 2005
'The Encounters in the 21st Century: Polyphony – Emerging Resonances', 21st Century Museum of Contemporary Art – Kanazawa, Japan 2004
Manifesta 5, San Sebastian – Spain 2004
'Sogni e Conflitti. La Dittatura dello Spettatore', Esposizione Internazionale d'Arte, Biennale di Venezia, section "La Zona" – Venice 2003
'Spectacular', Museum Kunstpalast – Düsseldorf 2003

In 2003 Tuttofuoco was awarded the Premio Artegiovane by the Associazione Artegiovane, Turin.

ACKNOWLEDGEMENTS

Studio Guenzani, Alessandra Pallotta, Barbara Gallucci, Pilar Corrias, Ben Tufnell, Antonio Paulic, Massimiliano Buvoli, Tommaso Previdi, P+P studio, Sabina Grasso, Damaso Queirazza, Sonia Leimer, Cook Fabrications, Folkestone, Light Engineering Folkestone Ltd., and the people of Folkestone.

The intent of this project is an attempt to (at least in part) metaphorically reshape the identity that Folkestone has lost during the past few decades by trailing the route of the Orient-Express from Istanbul to Folkestone. *Folkestone Express* re-establishes the ideas of circulation and mobility that used to link the town with Europe (coincidentally, William Harvey, who undertook pioneering research into the circulation of blood, was born in Folkestone in 1578).

Orient-Express is the name of a long-distance passenger train originally operated by the Compagnie Internationale des Wagons-Lits. For more than a century it has embodied glamorous and adventurous international railway travel, connecting different areas and cultures of the world, the "near east" with the Western countries of Europe.

The proposal for *Folkestone Express* was about a journey: to visit different cities connected with Folkestone via the Orient-Express and there to collect letters as the result of the different experiences, culminating in a sign-sculpture and a film.

The Orient-Express is chosen here as a vector connecting Folkestone's and Europe's history. Represented in the film and the sculpture, the journey acts as a way to re-create the sense of mobility and also as a symbol for multinationality linked by the railway, whose route includes Folkestone as one of its destinations. So Folkestone not only represents the final destination of a physical journey, but also the boundary of a symbolic organism, as it was when the town was part of greater European mobility and connection.

The resulting ten letters F-O-L-K-E-S-T-O-N-E represent the ten countries we crossed during the journey. Every letter has been taken from a different context and situation. We tried to follow a flow of energy. It was a challenge to find the right type of letter. Rather than just a technical or mechanical action, we tried to re-create and find the right energy around every single letter… and every letter tells a specific story… every letter has its own memory.

For example, **F** is a letter drawn by a former Second World War soldier, Antonio Paulic, who we met in Ljubliana just by chance. We explained our project and he offered to draw the first letter, F, especially for us. That is how our adventure started on the route of the Orient-Express. **L** is based on the neon tubes we saw in Bucharest's Nikola Tesla Museum (the inventor of free energy) that we lit up using our bodies as conductors of the energy. **K** evolved from the silhouette of a stunt biker who we chanced upon in the old centre of Sofia, in the middle of a cold Soviet square. And **N** presented itself as a construction made of a piece of cheese bought from a lady called Teresa in a Krakow street market.

Film made in collaboration with Mattia Matteucci and Andrea Pozzato.

Opposite:
Production still from *Folkestone Express*, video projection, 60 mins, 2008

Overleaf:
Folkestone, steel, paint 2.7 × 33.7m, 2008

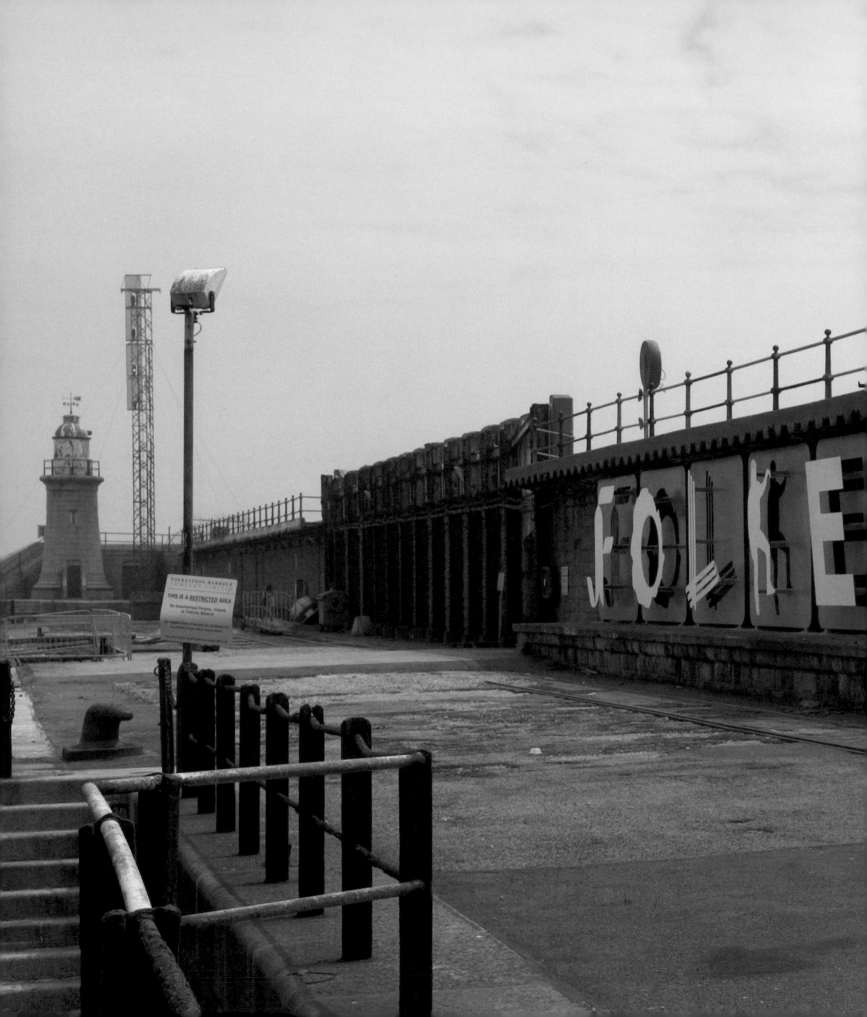

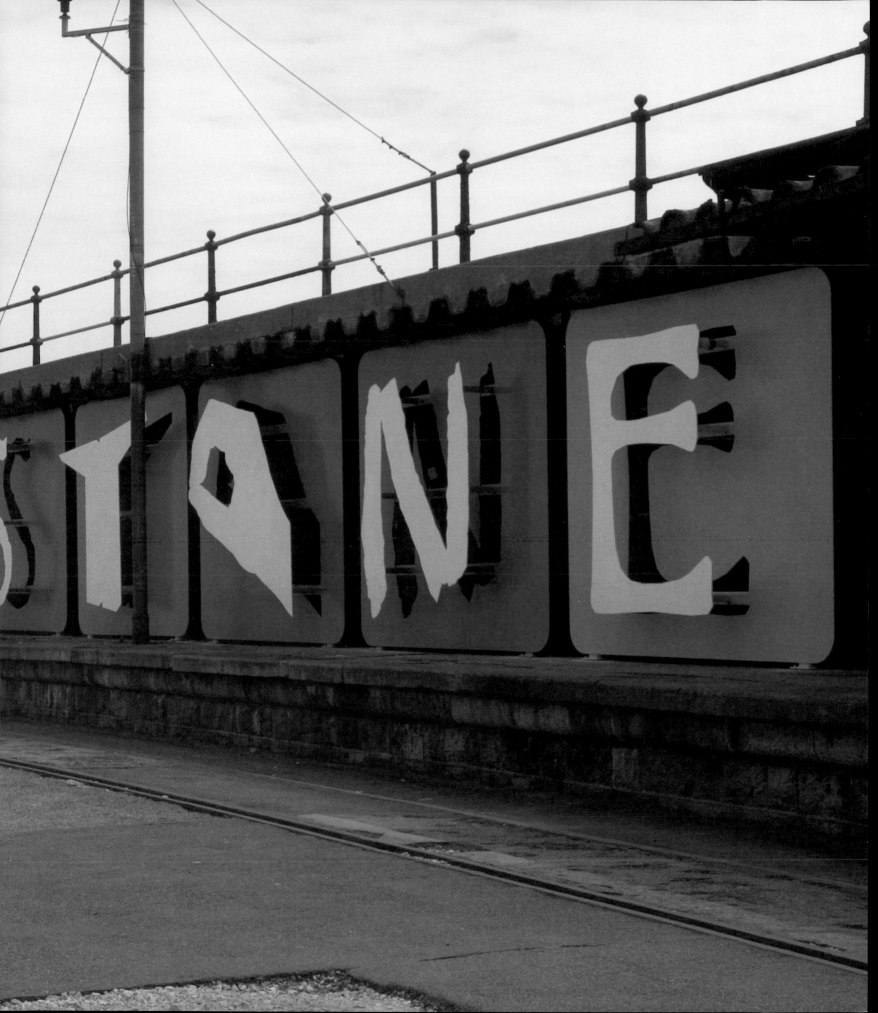

BORN

Chigwell, Essex, 1959. Lives and works in London.

Mark Wallinger is one of Britain's foremost contemporary artists. He is perhaps best known for *Ecce Homo*, a life-size sculpture of Christ that occupied the fourth plinth in London's Trafalgar Square in 1999. Since the mid-1980s his primary concern has been to establish a valid critical approach to the "politics of representation and the representation of politics" and has often explored issues of the responsibilities of individuals and those of society in his work. Wallinger has exhibited widely in the UK and internationally.

RECENT SOLO EXHIBITIONS

Kunstmuseum Aarau – Switzerland 2008
State Britain, MAC/VAL, Vitry-sur-Sein – France 2008
'Mark Wallinger', Kunstverein Braunschweig – Germany 2007
State Britain, Tate Britain – London 2007
'The Human Figure in Motion', Donald Young Gallery – Chicago 2007
The End/A ist für Alles, Anthony Reynolds Gallery – London 2006
Threshold to the Kingdom, Convent of St. Agnes of Bohemia, National Gallery – Prague 2006
'Mark Wallinger', Museo de Arte Carillo Gil – Mexico City 2005

RECENT GROUP EXHIBITIONS

'On Time: The East Wing Collection VIII', The Courtauld Institute of Art – London 2008
'The Turner Prize', Tate Liverpool – Liverpool 2007
Münster Sculpture Project – Münster 2007
'Timer 01 intimita/ Intimacy', Fondazione La Triennale di Milano/Triennale-Bovisa – Milan 2007
'Human Game', Stazione Leopolda – Florence 2006
'Aftershock: Contemporary British Art 1990-2006', China Art Gallery – Beijing and tour 2006
'When Humour Becomes Painful', Migros Museum fur Gegenwartskunst – Zurich 2005
'The Experience of Art', Italian Pavilion, La Biennale di Venezia – Venice 2005
'Miradas y Conceptos', MEIAC, Badajoz – Spain 2005
'The World is a Stage', Mori Art Museum – Tokyo 2005

Wallinger was awarded the Turner Prize in 2007. In 2001 he represented Britain at the 49th Venice Biennale and was also awarded the DAAD Fellowship.

ACKNOWLEDGEMENTS

MDM Props

MARK WALLINGER

FOLK STONES

Zero is an even number. 0 is neither positive nor negative. Zero is a number which quantifies a count or an amount of null size; that is, if the number of your brothers is zero, that means the same thing as having no brothers, and if something has the weight of zero, it has no weight. If the difference between the number of pieces in the two piles is zero, it means the two piles have an equal number of pieces. Before counting starts, the result can be assumed to be zero; that is the number of items counted before you count the first item and counting the first item brings the result to one. And if there are no items to be counted, zero remains the final result.

Almost all historians omit the year zero from the proleptic Gregorian and Julian calendars, but astronomers include it in these same calendars. However, the phrase Year Zero may be used to describe any event considered so significant that it serves as a new base point in time.

~

So Abram rose, and clave the wood, and went,
And took the fire with him, and a knife.
And as they sojourned both of them together,
Isaac the first-born spake and said, My Father,
Behold the preparations, fire and iron,
But where the lamb for this burnt-offering?
Then Abram bound the youth with belts and straps,
And builded parapets and trenches there,
And stretchèd forth the knife to slay his son.
When lo! an angel called him out of heaven,
Saying, Lay not thy hand upon the lad,
Neither do anything to him, thy son.
Behold! Caught in a thicket by its horns,
A Ram. Offer the Ram of Pride instead.
But the old man would not so, but slew his son,
And half the seed of Europe, one by one.

Opposite:
Folk Stones, work in progress

Overleaf:
Folk Stones, stones, paint, sand, cement, core-ten steel, 9 × 9m, 2008

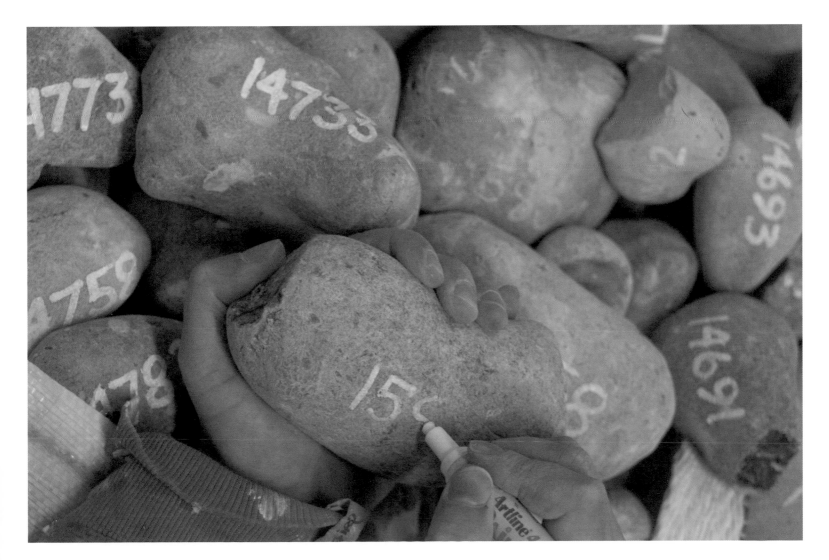

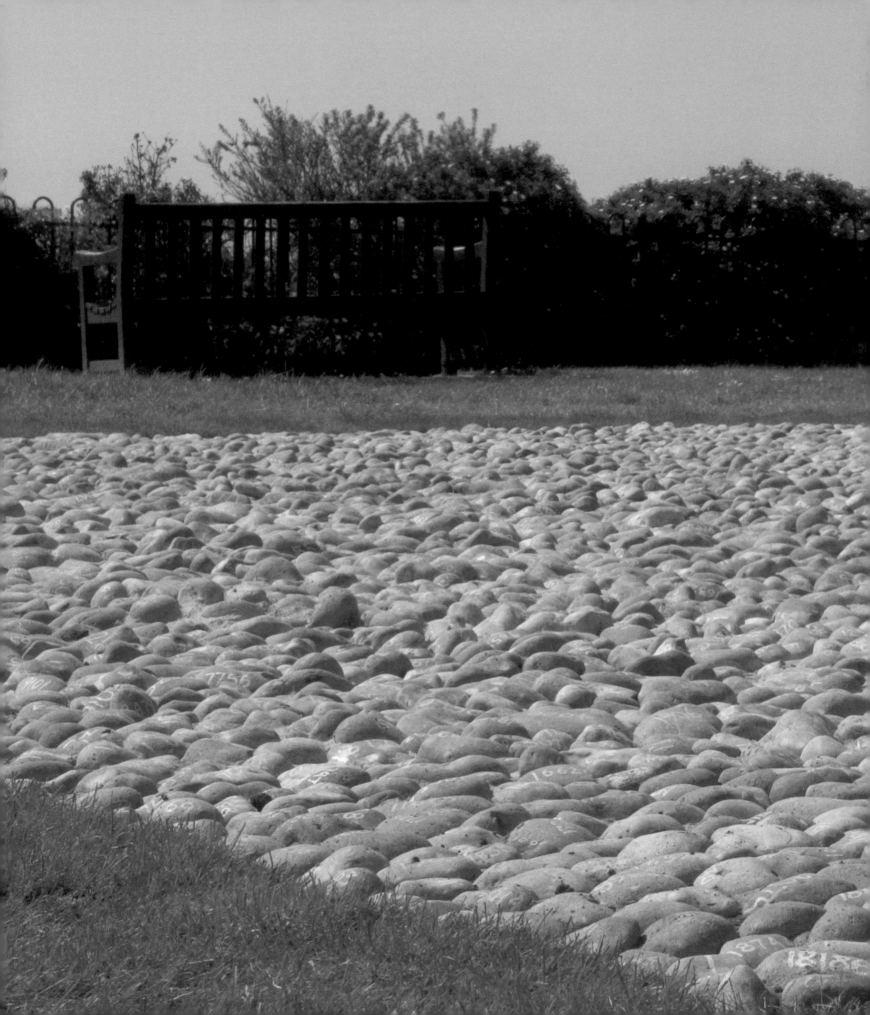

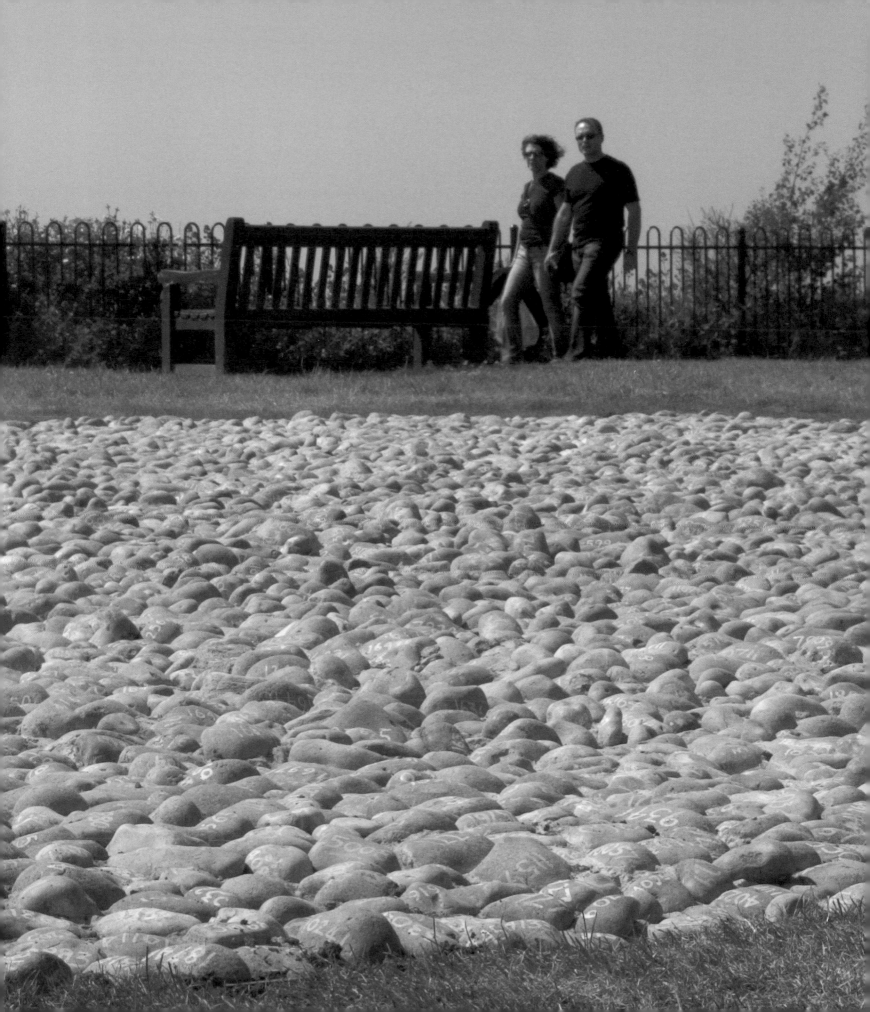

RICHARD WENTWORTH

RACINATED

BORN

Samoa, 1947. Lives and works in London.

Richard Wentworth has played a leading role in New British Sculpture since the end of the 1970s. His work, focusing on objects and their role in our daily lives, has radically altered the traditional definition of sculpture and reveals a spontaneous and surprising urban reality.

RECENT SOLO EXHIBITIONS

Pharos Centre for Contemporary Art – Cyprus 2006
Lisson Gallery – London 2005
Tate Liverpool – Liverpool 2005
'Glad that things don't talk', Irish Museum of Modern Art– Dublin 2003

RECENT GROUP EXHIBITIONS

'It Starts From Here', De La Warr Pavilion – Bexhill 2007
'Global Cities', Tate Modern – London 2007
'Out of Place', New Art Gallery – Walsall 2006
São Paulo Biennale – Brazil 2004.

Wentworth was awarded the DAAD Fellowship in 1993 and in 2002 was made Master of the Ruskin School of Drawing and Fine Art.

ACKNOWLEDGEMENTS

Shepway District Council, Clive Weatherhogg, Southcliff Hotel, Kay El-Shamma, Carlton Hotel, Clark's College (Properties) Ltd, Patrick Marrin, Dr Sandy Knapp, Natural History Museum, Piron Cooper, David Sephton, Alli Beddoes, Kit Grover, Cally Spooner, Will Holder and, of course, the magnificent John Yonge.

First close one eye, then the other, while opening the first. Alternate blinking performed in quick succession will displace the world before you.

As a child, long before I knew about Cézanne or the Cubists, I used to practise this as part of bedroom reverie, loving and puzzling in equal proportions, seeing the world judder and flicker. Growing up amidst the mobilised opportunities of post-war Europe, there were countless ways to expand my internal sense of cinema; the increasing speed at which landscapes could pass the framed glazing of trains and cars, the tunnel vision of the rear-view mirror, and the sky high dreams of watching terrain and ocean, both by night and by day, through the visor-like windows of commercial aircraft. It is a wonder that, amidst so much disorientation, we can still locate ourselves.

I recommend performing the blinking game in front of trees. There is nothing quite so special as getting a tree to jump about, since their confident claim in the land is such a deep reassurance to whirling humanity. It's not so much that trees are especially still, rather that they know their place and their season.

If you have ever witnessed a tree turn up, and lay claim to some special set of growing conditions, starting out small and coming up big, there are few things so confirming about a sense of purpose. Trees are not only legible, they can also read.

Some of the places which mean most to me are on the edge, at the end of the land, on borders, caught between natural, administrative or cartographic circumstances. These are often places where trees mind their own business and reclaim the territory for themselves. Like us, trees have narratives, origins, homes. They started out from somewhere and, like us, they are on their way to somewhere else.

Opposite:
Racinated, Holm Oak, vitreous enamel signs, 40 × 70 cm, 2008

Overleaf:
Racinated, Eucalyptus, vitreous enamel signs, 40 × 70 cm, 2008
Racinated, Buddleja, vitreous enamel signs, 40 × 70 cm, 2008

The Holm Oak (holm is an old word for holly) is an evergreen Mediterranean tree which enjoys a dry environment. It has been part of the English landscape for 200 years.

This Eucalyptus is typical of many which now grow in Europe. Eucalyptus were brought to Britain by explorers from their native Australia in the early 19th century. The tallest tree in the world is a species of Eucalyptus.

This Buddleja is an escape which colonizes vacant land. The French Jesuit priest Père David brought the *Buddleja davidii*, a native of China, to Britain in the early 19th century.

PAE WHITE

BARKING ROCKS

When I travel I miss home, I miss my pets. I become acutely aware of the local dog and cat life of whatever city I am visiting. In Folkestone, in addition to watching the dogs I found myself observing the dog owners, who appeared to be mostly elderly. Despite the obvious common bond, they were not interacting with each other at all. Instead, walking the dog seemed more for exercise, both for the owners and the dogs. However, due to the physical restrictions of the owners, their dogs seemed keen to exercise more; it is my belief that the dogs wanted to meet and play as well.

Barking Rocks hopes to address the needs of both the elderly and their canine companions. It takes a patch of neglected land ten by 25 metres, situated halfway between the shopping district and the ocean promenade, and turns it into a sort of playground for dogs. At the planning stage I asked for input from landscape designer (and dog maniac) Ivette Soler. Her keen observation was that dogs "like to go up…" and she showed me a picture of the natural basalt formations of Giant's Causeway, which became the inspiration for the *play mound*. Since the site is very compact, a vertical recreational device is a perfect solution. *Barking Rocks* consists of places where dogs can climb, places where they can play and mingle and places where owners can rest, talk, socialise. And viewers, or pet lovers, like me can be entertained. However, it not just for seniors and their dogs.

Below The Leas, two adventure-like playgrounds exist. One a sunken galleon and the other a fortress. By US standards, these are quite impressive, both in terms of their construction and in their invitation for fantasy play. The scale of these playgrounds makes it clear that they are for children of a certain age. With *Barking Rocks*, I hope to further the role-playing dialogue by proposing an extension of these play activities, but one for dogs. Perhaps clubhouse, or even a pirates' clubhouse? But in this case the pirates are dogs. "*No cats allowed… or else…*" Playful references, to play itself and the visual potential that watching "play" has to offer.

Volunteering in a convalescent home taught me the loneliness, shyness and sheer isolation that people face in their later years. My hope is that even people without dogs will come to *Barking Rocks* to watch the dog activity as a sort of landscape theatre, that over time it emerges as a place of fun and friendship. And with the companionship and humour that dogs bring to people, a subtle type of outreach will occur, both for the human and non-human population alike.

Opposite:
Barking Rocks, (detail), steel paint, cold-cast bronze

Overleaf:
Barking Rocks, wood, plants, enamel signage, LED lighting, soil and concrete, 5 × 12m, 2008

BORN

USA, 1963. Lives and works in Los Angeles.

RECENT SOLO EXHIBITIONS

'Mr. Baci e Abbracci', galleria francesca Kaufmann – Milan, Italy 2008
'Lisa Bright and Dark', Scottsdale Museum of Contemporary Art – Arizona 2008
'Too Much Night', neugerriemschneider – Berlin 2007
Hirshhorn Museum and Sculpture Garden – Washington DC 2007
'Get Well Soon', greengrassi – London 2006
Manchester Art Gallery and Milton Keynes Gallery, UK
Hammer Museum – Los Angeles 2004

ACKNOWLEDGEMENTS

David Parfitt at Transformations, Chris McCreedy, Laura Pinkham and Yvette Soler at Shepway District Council.

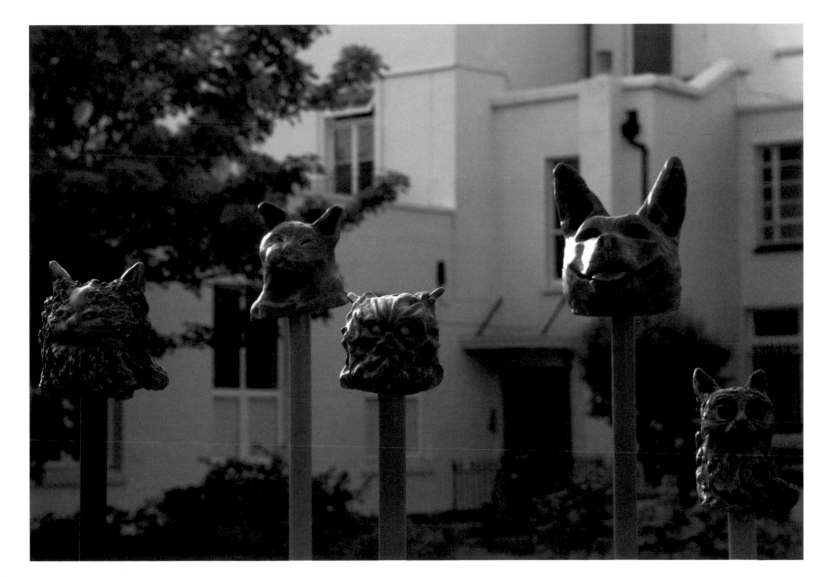

RICHARD WILSON

Hi Andrea
Just to say thanks for the invitation and that I'm excited to be involved in the project.

Hi Andrea
Am caught up with various stuff at present, so I have not been on the case re a reworking of the gig, but do have some thoughts that I could discuss to push all forward.

Hi Andrea
The 6th @ 1.30 is fine. Any ideas of where there is a quiet, spacious coffee house that does delicious unhealthy food?

Hi Andrea
Yes it's me, resurfacing... I know, "we are all busy", but... I have been thru the mill for the last five months with projects being either researched, costed, built, inspected or salvaged, along with invading builders and a friend's death. I contemplated turning to drink and other stimulants, but then realised I'm already...
... ssssssooooooo, FFFFFolkestone... I am of course totally committed. I have looked at the latest idea and am working now on a set of first draft sketches to realise this work as an architectural sculpture in concrete (no vandalism). As soon as this first draft is honed sharp I will send the sketches thro and this will probably be very late next week bearing in mind I am back and forth now to Liverpool every week to sign off a work.

Hi Andrea
I can see from your press launch date that I am behind in informing you re the set of working first draft sketches. I have to say this is not unusual when struggling to get the best from me. The piece is still not in its right configuration (Don't panic something worthwhile is coming). To simply describe where the idea is... "Playful, sandcastle principle, architectural, epitomises the seaside, from the written off comes a new order, a hint of a future Folkestone, recovered material speaking of a recovering town, nostalgic, historic, mimicking the redevelopment of the sea front, brutal in form, bunker, sea defences, comic, talks of the need of reinvention from a past and the notions of regeneration, copies the dilapidated to refurbishment model for the town."

Hi Andrea
Tuesday's trip to Folkestone was very rewarding. Will be cutting slabs/material to construct X3 beach huts along the sea front walk to the Mermaid Café. They are, however, not made of the usual wooden planking, but are cut from concrete slabs that make up the now abandoned eighteen-hole crazy golf course located at the back of the esplanade. Each hut comprises six measured panels that come together as a series of planes or slabs. The eighteen-hole course will provide material for X3 huts.

Hi Andrea
As promised, some images and two sheets of words to dwell on. I have tried to consider all the cost factors as a list, but no figures yet. Let's talk "eighteen holes" again after the "hols".

Hi Andrea
I need to get down soon to make an exploratory dig and find out what we have on the make up of the concrete course. I will give you enough time to clear the necessary permissions just in case some pensioner thinks I'm burying a body.

Hi Andrea
That is absolutely fine, no problem with doing a text and we are continuing to document all that is taking place at that "Crazy" site. Text will be along the lines of...

Opposite & overleaf:
18 Holes, excavated concrete slabs, artificial lawn, paint and steel, 2.62 × 8.53 × 3.05m, 2008

BORN

UK, 1953. Lives and works in London.

Richard Wilson is one of Britain's most renowned sculptors. He is internationally celebrated for his interventions in architectural space, which draw heavily from the worlds of engineering and construction for their inspiration, and has exhibited widely nationally and internationally for more than 30 years.

RECENT SOLO EXHIBITIONS

Turning the Place Over, lead work for Year of Culture – Liverpool 2007
Galleria Fumagalli, Bergamo – Italy 2007
Curve Gallery, Barbican Art Centre – London 2006
Bank Job, Caveau, Palazzo delle Papesse Contemporary Art Centre – Italy 2004

RECENT GROUP EXHIBITIONS

Royal Academy Summer Show – London 2007
Butterfly, Platform China – Beijing 2006
Break Neck Speed, Yokohama Triennial – Japan 2005

Wilson was nominated for the Turner Prize on two occasions and was awarded the DAAD Fellowship in Berlin 1992/1993. He was made a Royal Academician in 2006.

ACKNOWLEDGEMENTS

David Bowen and Tony Hatton.

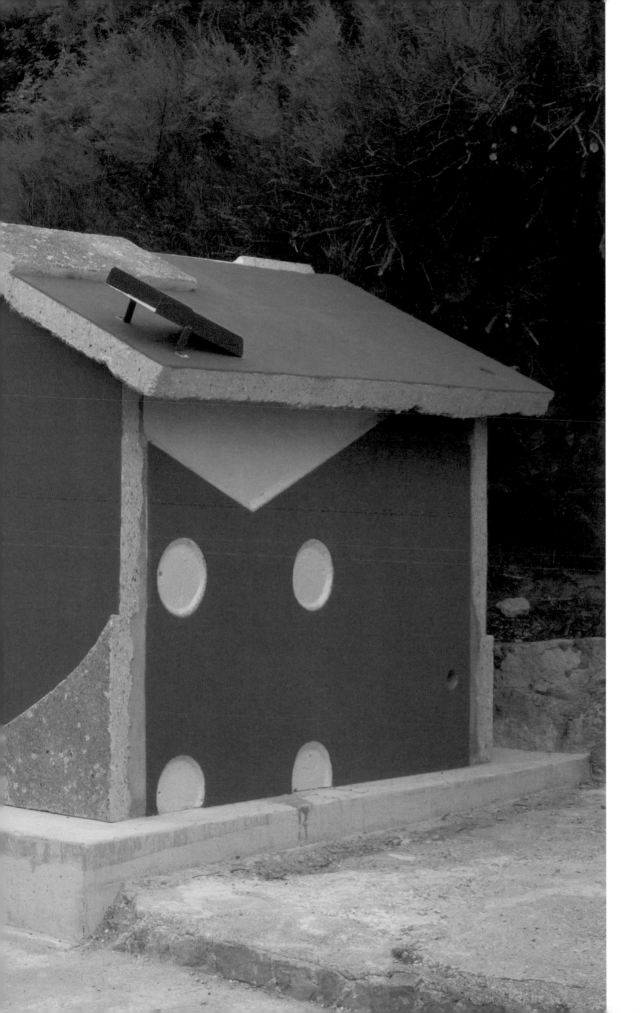

LOCATIONS

1 DAVID BATCHELOR
2 CHRISTIAN BOLTANSKI
3 ADAM CHODZKO
4 NATHAN COLEY
5 TACITA DEAN
6 JEREMY DELLER
7 MARK DION
8 TRACEY EMIN
9 AYSE ERKMEN
10 SEJLA KAMERIC
11 ROBERT KUSMIROWSKI
12 LANGLANDS & BELL
13 KAFFE MATTHEWS
14 HEATHER & IVAN MORISON
15 NILS NORMAN WITH GAVIN WADE MIT SIMON & TOM BLOOR
16 SUSAN PHILIPSZ
17 PUBLIC WORKS
18 PATRICK TUTTOFUOCO
19 MARK WALLINGER
20 RICHARD WENTWORTH
21 PAE WHITE
22 RICHARD WILSON

● MULTI-SITE ARTWORK

➡ MOBILE ARTWORK
The location of the mobile works will change daily. Please check the visitor centre or visit www.folkestonetriennial.org.uk for details.

//////////////////////////////////////

ℹ FOLKESTONE TRIENNIAL VISITOR CENTRE

P PARKING

🚻 TOILETS

♿ DISABLED TOILETS

🚼 BABY CHANGING FACILITIES

🚌 BUS STATION

🚉 RAILWAY STATION

T TALK & TOUR START POINT

▢ GRASSED AREAS

▤ ESCARPMENT / CLIFF

▢ PEBBLED BEACH / REEF

▢ SANDY BEACH

▨ PEDESTRIAN AREAS

- - DISUSED RAILWAY TRACK

Scale: ¼ mile

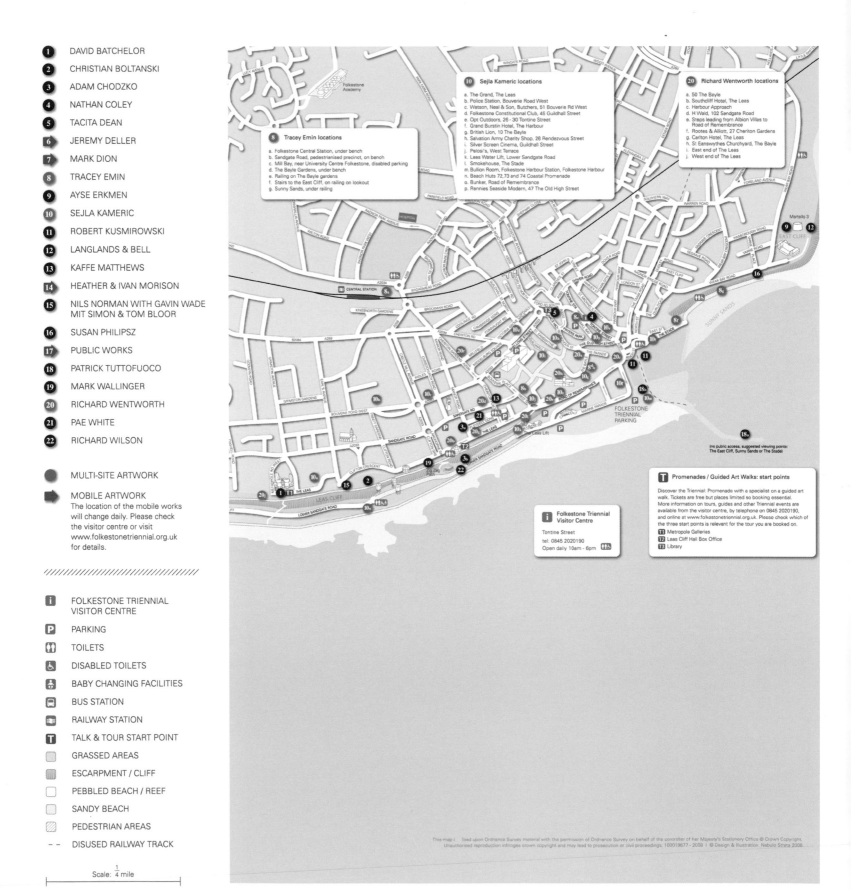

8 Tracey Emin locations
a. Folkestone Central Station, under bench
b. Sandgate Road, pedestrianised precinct, on bench
c. Mill Bay, near University Centre Folkestone, disabled parking
d. The Bayle Gardens, under bench
e. Railing on The Bayle gardens
f. Stairs to the East Cliff, on railing on lookout
g. Sunny Sands, under railing

10 Sejla Kameric locations
a. The Grand, The Leas
b. Police Station, Bouverie Road West
c. Watson, Neal & Son, Butchers, 51 Bouverie Rd West
d. Folkestone Constitutional Club, 45 Guildhall Street
e. Opt Outdoors, 26 - 30 Tontine Street
f. Grand Burstin Hotel, The Harbour
g. British Lion, 10 The Bayle
h. Salvation Army Charity Shop, 28 Rendezvous Street
i. Silver Screen Cinema, Guildhall Street
j. Pelosi's, West Terrace
k. Leas Water Lift, Lower Sandgate Road
l. Smokehouse, The Stade
m. Bullion Room, Folkestone Harbour Station, Folkestone Harbour
n. Beach Huts 72,73 and 74 Coastal Promenade
o. Bunker, Road of Remembrance
p. Rennies Seaside Modern, 47 The Old High Street

20 Richard Wentworth locations
a. 50 The Bayle
b. Southcliff Hotel, The Leas
c. Harbour Approach
d. H Wald, 102 Sandgate Road
e. Steps leading from Albion Villas to Road of Remembrance
f. Rootes & Alliott, 27 Cheriton Gardens
g. Carlton Hotel, The Leas
h. St Eanswythes Churchyard, The Bayle
i. East end of The Leas
j. West end of The Leas

(no public access, suggested viewing points: The East Cliff, Sunny Sands or The Stade)

ℹ Folkestone Triennial Visitor Centre
Tontine Street
tel: 0845 2020190
Open daily 10am - 6pm

T Promenades / Guided Art Walks: start points
Discover the Triennial: Promenade with a specialist on a guided art walk. Tickets are free but places limited so booking essential. More information on tours, guides and other Triennial events are available from the visitor centre, by telephone on 0845 2020190, and online at www.folkestonetriennial.org.uk. Please check which of the three start points is relevant for the tour you are booked on.
T1 Metropole Galleries
T2 Leas Cliff Hall Box Office
T3 Library

This map is based upon Ordnance Survey material with the permission of Ordnance Survey on behalf of the controller of her Majesty's Stationery Office © Crown Copyright. Unauthorised reproduction infringes crown copyright and may lead to prosecution or civil proceedings. 100019677 - 2008 i © Design & Illustration: Nebula Strata 2008

1 David Batchelor (1955, UK): 'Disco Mécanique'

Metropole Galleries, The Leas
Multi-coloured spheres created from thousands of plastic sunglasses rotate silently, suspended from the ceiling of the former ballroom of the Metropole Hotel. Limited access

2 Christian Bołtanski (1944, France): 'The Whispers'

West end of The Leas
Sound work installed at four benches on the coastal side of the Leas path (near Clifton Crescent), playing a recording of voices reading letters to and from servicemen who passed through Folkestone in the First World War. Fully accessible.

3 Adam Chodzko (1965, UK): 'Pyramid'

*Coastal park, below the Leas Cliff Hall &
The Stone Store, Shakespeare Terrace*
The work consists of a film and a 'fake' visitor information sign. The information sign, designed in the style of Shepway District Council signage, can be found in the Coastal Park, beneath the Leas Cliff Hall. The related film is screened in The Stone Store, Shakespeare Terrace. Both sites fully accessible.

4 Nathan Coley (1967, UK):
'Heaven Is A Place Where Nothing Ever Happens'

The Old Post Office, 48 Tontine Street
Raised high on the roof of the building, a free standing scaffolding structure houses an illuminated sign created from fairground bulbs. Fully accessible.

5 Tacita Dean (1965, UK):
'Amadeus (swell consopio)'

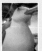

Sassoon Gallery, upstairs in Library
16mm colour anamorphic film, mute, 50 minutes, featuring a dawn crossing from Boulogne to Folkestone in an old fishing vessel.
Fully accessible: lift located at rear of library.

6 Jeremy Deller (1966, UK): 'Risk Assessment'

Various
A series of unannounced daily performances based on the comic tradition of Buster Keaton and Jacques Tati is presented by local amateur dramatists throughout the town and seafront. Performances between 2pm and 4pm daily.

7 Mark Dion (1961, USA):
'Mobile Gull Appreciation Unit'

Mobile (check daily location in Visitor Centre and on website)
A giant replica seagull on wheels, staffed by a gull expert, the Unit also includes a small library. Its mission is to promote the appreciation of this often unloved bird family. Access dependent on site.

8 Tracey Emin (1963, UK): 'Baby Things'

Various
Seven bronze castings of found items of baby clothing are located at sites throughout Folkestone. Tucked under a bench or hanging on a railing, the sculptures appear as though they were lost, waiting to be found, making reference to the high proportion of teenage pregnancy in Folkestone. Access dependent on site.

9 Ayse Erkmen (1949, Turkey): 'Entangled'

Martello Tower 3, East Cliff
Draped in a green, red, and white plastic material called 'Algue' (designed by E. & R. Bouroullec) Martello Tower No. 3 has been given a camouflage cover recalling its militaristic history. Intended by the artist as a designed and simulated material to rival the ivy at the western Martello Tower 4, the result is a dramatic curtain enshrouding this well-known monument built during the Napoleonic Wars. Limited access.

10 Sejla Kameric (1976, Bosnia & Herzegovina):
'I Remember I Forgot'

Various
Twelve photographic installations in public spaces (shop, cafe, cinema etc.) and a set of six large-scale posters in specially selected sites across the town document the changing face of Folkestone. The complete set of images and stories can be purchased as postcards at Rennies, 47 The Old High Street.
Access dependent on site.

11 Robert Kusmirowski (1974, Poland): 'Foreshore'

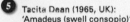

Inner Harbour beside Gigi's Café and outer harbour
A life-size replica historical fish market, installed in the inner harbour next to Gigi's and outer harbour at the base of the Cabin Café. Only fully visible at low tide. To be viewed from the harbour market square and The Stade. No access.

12 Langlands & Bell (1955 & 1959 respectively, UK):
'Folkestone : Boulogne'

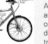

National Coastwatch Institution, East Cliff
A 15 minute video of the artists' observational study of the two towns. Screening in Copt Point, the Coastwatch Station on the East Cliff. Limited access.

13 Kaffe Matthews (1961, UK): 'The Marvelo Project'

91 Sandgate Road
A Folkestone 'Opera', jointly created by the artist and year 11 pupils from Folkestone Academy. The composition is heard from speakers attached to specially designed 'Marvelo Project' bicycles, fitted with a GPS tracking system. Bicycles available from 91 Sandgate Road. Operatic scores also exhibited here. Musical experience accessible to cycle riders only.

14 Heather and Ivan Morison (1973 & 1974 respectively, UK): 'Tales of Space and Time'

Mobile (check daily location in Visitor Centre and on website)
A Science Fiction library in the style of a 1970s Californian House Truck will journey around the town. A series of related talks will run throughout the summer. For further information about the talks and locations of the mobile library please contact the Visitor Centre or check the Folkestone Triennial website.
Access dependent on site.

15 Nils Norman, with Gavin Wade mit Simon & Tom Bloor (1966, 1971, 1973 respectively, UK):
'Kiosk 5: Kite Kiosk'

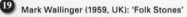

West end of The Leas, in front of Clifton Crescent
A 1930s Lubetkin style kiosk, installed on The Leas near Clifton Crescent. The kiosk is staffed to distribute specially produced kites and booklets.
Fully accessible.

16 Susan Philipsz (1966, UK): 'Pathetic Fallacy'

The outlook at Baker's Gap - on the steps joining East Cliff and the Sunny Sands Promenade
A multi-speaker sound installation of the artist singing a rendition of 'Dolphins' (made famous by Tim Buckley), installed in Baker's Gap. Limited access.

17 Public Works (Kathrin Böhm 1969, Germany; Andreas Lang, 1968, Germany; Torange Khonsari 1973, Iran):
'Folkestonomy'

Mobile (check daily location in Visitor Centre and on website)
A converted milk float, located at various sites around Folkestone, by this London-based art and architecture collective. It acts as a 'hub' for Folkestone Triennial visitors to record their experiences and become part of a mapping project exploring cultural regeneration. Access dependent on site.

18 Patrick Tuttofuoco (1974, Italy):
'Folkestone Express'

Harbour Arm and Harbour Information Centre
Installed on the Harbour Arm, letters and letter-shapes encountered on a journey following the route of the Orient Express (which comes to Folkestone every week) spell out the name of the town and welcome visitors, boats and ships. No access to the sign, to be viewed from afar.
Follow the artist and his collaborators on their trip in a video installation shown in the Harbour Information Centre. Fully accessible.

19 Mark Wallinger (1959, UK): 'Folk Stones'

West end of The Leas, close to the William Harvey Statue
19,240 beach pebbles have been numbered and placed on the Leas. A monument to those who lost their lives on the first day of the Battle of the Somme, many of whom marched down Folkestone's Road of Remembrance before disembarking for the battlefields of France and Flanders. Fully accessible.

20 Richard Wentworth (1947, Samoa): 'Racinated'

Various
A series of deep blue enamel signs can be found throughout the town informing visitors of the origins of non-native trees which have made a home in Folkestone. Access dependent on site.

21 Pae White (1963, USA): 'Barking Rocks'

Pleydell Gardens
'Barking Rocks' is a park designed for dogs and their owners. A previously dilapidated piece of land has been transformed into 'landscape theatre'. The artist was inspired by the many dogs of Folkestone and their often elderly owners. Fully accessible.

22 Richard Wilson (1953, UK): '18 Holes'

Coastal Promenade, nr. Mermaid Café
The crazy-golf putting green from the former Amusement Park is refurbished and its parts re-assembled to create three Folkestone style beach huts. Fully accessible.

THANKS AND ACKNOWLEDGEMENTS

ACTIV
PAUL ALLEN
MARJORIE ALLTHORPE GUYTON
GREGORY AMBOS
CLAUDIA AMTHOR-CROFT
LEILA APPLEBY
EMMA ASTNER
DAVID ATKEY

KARIN BACKLOG
THIERRY BAL
TIM BARRY
ALLY BEDDOES
STELLA BELLEM
LEWIS BIGGS
GILL AND JOHN BLOOM
MIKE BLOW
BENEDICK BLYTHE
RICHARD BLYTHE
SIMON BOLTON
ALYSSA BONIC
AMY BONICIMOMPALAO
RONAN & ERWAN BOUROULLEC
THOMAS BRASINGTON
DANIEL BRENNAN
MIKE BRETT
RACHEL BROWN
NICOLA BRUCE
RUSSELL BURDEN
LEO BURLEY

FIONA CABASHE
CAFÉ IT
RICHARD CALVOCORESSI
STEPHANIE CAMU
KEITH CANE
JANE CHAMBERS
STEVE CHAMBERS
PHILIP CLAPHAM
SOPHIE CLAUDEL
ANTIGONE CLAYTON
CLUB SHEPWAY
SANDRA COHEN
LEIGH COLLINS
PIRAN COOPER
OLIVER CRAGG
DEBBIE CROFTS
KEZIAH CUNNINGHAM
MIKE DAVEY
DUANE DAVIS
OB DAVIS
SARA DE BONDT
ELLEN DE BRUIJNE PROJECTS, AMSTERDAM

AMICIA DE MOUBRAY
GAUTIER DEBLONDE
AARON DEWHURST
LYNN DOCKAR
DAVE DOWN
ANN DREW
RAY DUFF

SIAN EDE
KAY EL-SHAMMA
KATE ELLWOOD
CHRIS ESSEX
MARGARET EVANS
LAUREN EVANS
CHARLES EVANS
ANDREW EVERETT

FRANCESCA FINDLATER
ALAN FITZGERALD CLARK
EMMA FLOWER
FHODS
FOKSAL GALLERY FOUNDATION, WARSAW
FOLKESTONE ACADEMY
FOLKESTONE CLASSIC FILM CLUB
FOLKESTONE AND DOVER WATER
FOLKESTONE HARBOUR COMPANY LTD
FOLKESTONE MIGRANT SUPPORT GROUP
FOLKESTONE MOSQUE
FOLKESTONE TRAWLER COMPANY
FOLKESTONE YATCH & MOTORBOAT CLUB
VICTORIA FOSTER
SANDRA FRANCIS
JEMMA FRANCIS
RICHARD FRASER
FRITH STREET GALLERY, LONDON
JULIA FURNESS

DAVID GATRELL
CANDIDA GERTLER
ABI GILCHRIST
HAYLEY GILLINGHAM
ELIZABETH GILMORE
ESME GODDEN
MELITA GODDEN AND KITTY & STANLEY
PETER GODDEN
MARIAN GOODMAN GALLERY, PARIS
KEN GRAHAM
JOHN GREEN
KATE GREENAWAY
GREENGRASSI, LONDON
GRIGGS OF HYTHE

HERSH HALADKER
HAUNCH OF VENISON, LONDON
LESLEY HARDY
CLIVE HARRIS
PAUL HARRIS
FELICITY HARVEST
HAUNCH OF VENISON, LONDON
PROF. DAVID HAYWARD
CATHERINE HERBERT
TIM HICKLING
ALEXANDRA HILL
HIVE NETWORKS
ALISON HOLDOM
STEVE HOLLEY
TIM HOLMES
MATHEW HOLLOWAY
ROSIE HOLROYD
JOHN HUGGINS
JERRY HUGHES
HYTHE YOUTH CLUB

ALFONSO IACURCI
IMPERIAL WAR MUSEUM

SANDRA JANMAN
MARIA JOHNSON
RAY JOHNSON
LARRY JONES
NICK JONES
JAY JOPLING/ WHITE CUBE, LONDON

PETER KEMP
CLAIRE KENNETT
RACHEL KENT
DAVE KINNEAR
KITEWORLD

SANDY KNAPP
PENNY KNATCHBULL
IRIS KUNTZ

IAN LANDER
NICK LAWN
JAN LEANDRO
STEPHEN LEVINE
MARY ANN LE LEAN
JORIS LINDHOLT
LISSON GALLERY, LONDON
JULIE LOMAX
JANE LUCK
IAN LUCK
GEOFFREY LUDLOW
GREG LYNCH

PATRICK MARRIN
SANDRA MATTHEWS-MARSH
LEN MAYATT
LYNNE MAYER
IAN MCARTHUR
COLIN MCCADDEN
CHRIS MCCREEDY
GREG MCDOWELL
ANDY MCGEORGE
KAREN MCLENNAN
NIGEL MEESON
MITCH MITCHELSON
ROOD MOLLEMAN
LONE BRITT MOLLOY
DORIAN MOORE
JOANNA MOORE
BEN & RACHEAL MOORHEAD
PAMELA MORRIS
ANNE MORTIMER

ANNA NASH
NEBULO STRATA
SEB NEERMAN
FERN NEYLAN
GILES NICHOLAS

AMANDA OATES
BRIGITTE ORASINSKI

DAVID PARFITT
ROSS PATRICK
COLIN PAYNE
YANA PEEL
CLIVE PHILLIPS
THOMAS PHONGSATHORN
LAURA PINKHAM
JASON PITTOCK
DAN PORTER
CHRIS PRICE
SUSAN PRIEST

ELAINE RAFFERTY
DAVID REDHEAD
PAUL AND KAREN RENNIE
ANTHONY REYNOLDS, LONDON
GLYN RICHMOND
JOHN RIDLEY
ANDY ROBERTS
CARL ROBERTSHAW
JUDITH ROEBUCK
KATE ROHDE
EAMONN ROONEY
ANDY ROSS

CLAUDIA ROSSLER
MATT ROWE
RUSSELL AND WHEELER

PAT SEGGERY
DAVID SEPHTON
ROSEMARY SIEBERT
BEV SHEPPARD
DANA SHERWOOD
SHORESIGN
GRAHAM SOUTHERN
ROB SPICKETT
CALLY SPOONER
PAT STOREY
STRANGE CARGO
MIKE STRANKS
PAUL SULSH
JOHN SUNLEY

SALLY TALLANT
ROY TANDY
EMMA-JAYNE TAYLOR
THE MODERN INSTITUTE, GLASGOW
DAVE THOMAS
JAMIE THOMSON

NICK & ZOE VARIAN

SANDY WALLACE
ANDY WALLER
ALICE WALTON
JAMES WARNER
MARINA WARNER
A.J. WELLS AND SONS
LORE WESCHKE BOYD & VINN
STAN & CORRAL WHITEHOUSE
ROBBY WHITFIELD
JEREMY WHITTAKER
PATRICK WILKINSON
WILKINSON GALLERY, LONDON
ALAN WILLETT
WILLIAMS RADIO & ELECTRICAL
GARETH WILLIAMS
DAVE WILLIAMS
SOO WILLIAMS
PIP WITTENOOM
JENNY WOMERSLEY
RACHEL WOODHOUSE
TOM WRIGHT
JOHN YONGE

Folkestone Triennial:
Tales of Time and Space
14 June to 14 September 2008
www.folkestonetriennial.org.uk

First published in Great Britain
in 2008 by Cultureshock Media Ltd,
on behalf of
The Creative Foundation
The Block
65-69 Tontine Street
Folkestone
CT20 1JR
T +44 (0)1303 245799
F +44 (0)1303 223761
www.creativefoundation.org.uk

Curator: Andrea Schlieker
Assisted by Kim Dhillon,
Niamh Sullivan, Jessica Wythe,
Martin Wills

Page 56, extract from from *Strangeland* by
Tracey Emin © 2005, reproduced by kind
permission of Hodder & Stoughton.

Page 100, *The Parable of the Old Man and the
Young* by Wilfred Owen

Map design: Nebulo Strata

A CIP catalogue record for this book is
available from the British Library
ISBN 10: 0-9546999-6-3
ISBN 13: 978-0-9546999-6-3

Editor: Andrea Schlieker
Sub editor: Ian Massey
Production Manager: Nicola Vanstone
Publishing Director: Phil Allison
Creative direction: GTF
Installation photography: Thierry Bal
Images of Folkestone: Joel Tettamanti
Photography: Gautier Deblonde, Martin Wills
Printed by Cambridge University Press

Cover image by Joel Tettamanti

Cultureshock Media
27b Tradescant Road
London
SW8 1XD
T +44 (0)20 7735 9263
F +44 (0)20 7735 5052
www.cultureshockmedia.co.uk

cultureshock

Distributed by: Thames & Hudson
181A High Holborn
London
WC1V 7QX
T +44 (0)20 7845 5000
F +44 (0)20 7845 5050